Artist's Sketchbook

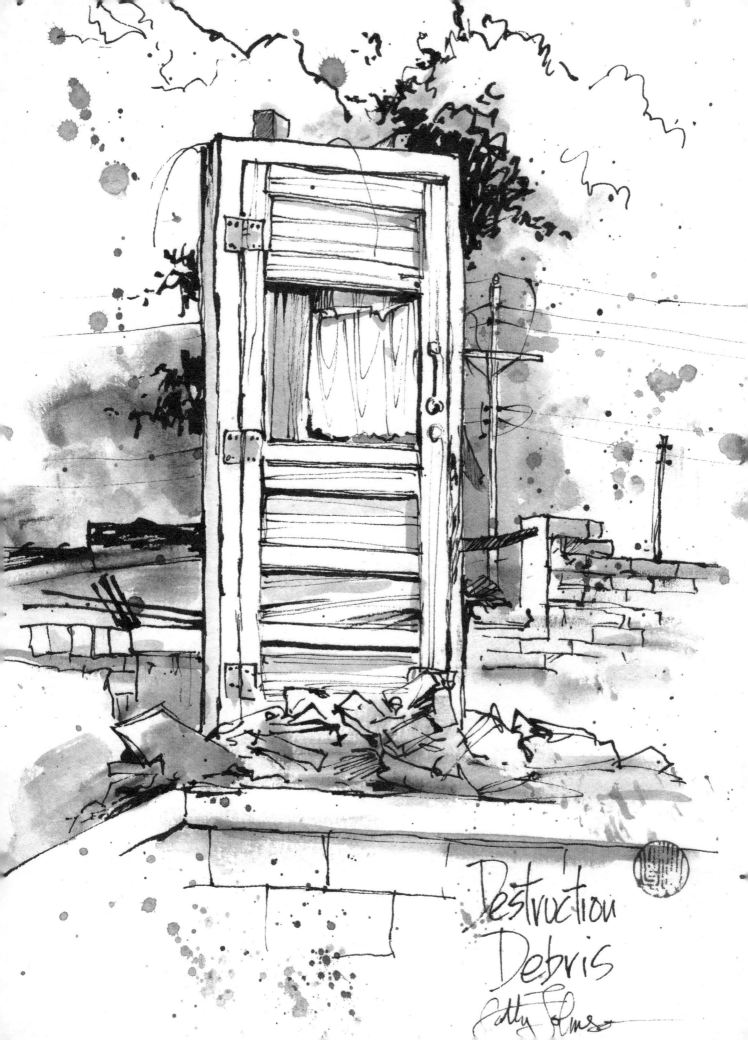

Destruction
Debris

Artist's Sketchbook

Exercises and Techniques for Sketching on the Spot

Cathy Johnson

NORTH LIGHT BOOKS
CINCINNATI, OHIO
artistsnetwork.com

Contents

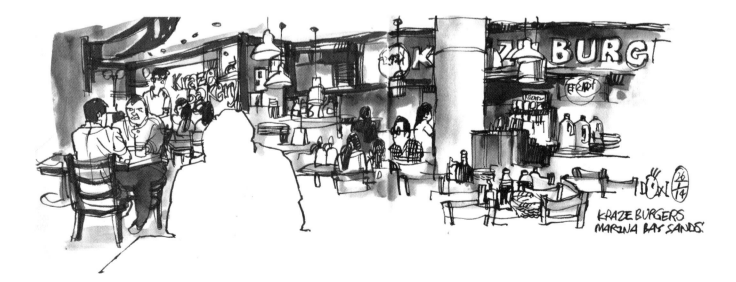

What You Need

Surface

cold pressed watercolor paper

hot-pressed watercolor paper

multimedia sketchbook or journal

Pigments

assorted watercolors

Brushes

½" (1.25cm) and 1" (2.5cm) flats

nos. 8, 10 and 12 rounds

small bristle

small, medium and
large waterbrushes

Other

calligraphy pen

black ink pen

graphite pencil

wax-based colored
pencils (like Prismacolor)

white gel pen

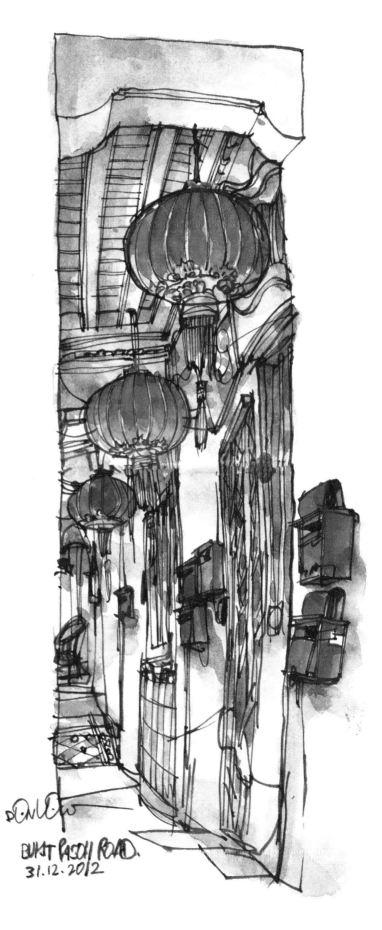

BUKIT PASOH ROAD.
31.12.2012

Introduction

There is something so immediate, so personal, so beguiling about working on the spot. Unlike working from a photo or from one's imagination, everything around us informs our sketch. It becomes part of it, lending it a depth and a freshness that studio work seldom seems to achieve.

We notice things that may have nothing to do with what we're sketching, but we remember them years down the road, every time we open that sketchbook or journal. We respond on a deep level, whether we fully realize it or not. Our emotions join our intellect and memory to appear, as if by magic, on the page. A sense of peace or wonder may envelop us, or a flare of anger as we remember the damage done by vandals to a favorite picnic spot. I can still smell the tang of broken, rusty metal and old campfire ashes that were present when I sketched the old stone barbecue in our local park.

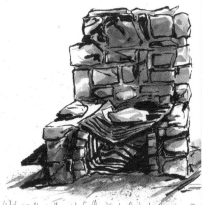

What, exactly, is the point of this kind of destructiveness? Damned One-minded people

Stone Barbecue
I like to let my emotions show in my sketches. In this case, the bold, black marks made with a brush pen served much better than a delicate rendering of this stone barbecue.

We discover things we never thought to look for when we set out to sketch a delicate feather that teases us with the mystery of its owner, a tiny Irish bistro set in an alley in a bustling city, a bakery or fish market that's been in the same family for three generations, a magnificent tree deep in the forest or a wildflower we've never seen before, right in our own backyard.

Sketching on the spot doesn't necessarily require being "out amongst 'em." We don't have to set up in a public place or deal with anxiety or discomfort. You can sketch on your own front porch, from your window, from your car, alone in nature or in your studio from some interesting item you've carried home. "The spot" refers to where you are. It means working from life.

We may find plenty to draw in our own backyard, or we may take off on foot to El Camino like artist Jennifer Lawson, or to the High Sierras like Kolby Kirk. The world is out there, near and far, waiting to be discovered and drawn.

We may find a tumble of stone ruins in Ireland or towering palm trees in the Sinai. Irish artists Róisín Curé and Shevaun Doherty share their sketches from their explorations at home and abroad, and invite us along. Laura Murphy Frankstone sketches wherever she is, whether she's depicting the flowers in her own garden, Norway's frozen fjords or sunny Italy. Roz Stendahl delights in traveling with as little gear as possible as she sketches standing up at the Minnesota State Fair. Nina Khashchina takes us on an artist-in-residency in Alaska and shares how she prepared for the trip of a lifetime. Warren Ludwig's wide-reaching interests take him from air shows to dinosaurs.

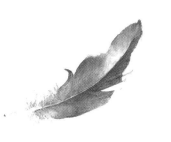

Duck Feather
Australian artist Alissa Duke creates the most delicate, wondrous duck feathers with watercolor pencils.

My own sketches-on-the-spot range from my Missouri bird feeders to the Pacific coast, to the tide pools of Maine and the arid Southwestern desert.

This is not a book on plein air painting, though there is some of that. We are more focused on sketching, capturing our impressions, honoring our passing hours and responding to whatever we see, indoors or out.

Like any good trip, wherever you go, the secret is to be prepared but not *too* prepared. Leave room for serendipity, for thinking on your feet, for surprises and delight and flexibility. You may discover a new approach or a new tool that will become part of your artistic vocabulary for a lifetime. You may find yourself "stuck" in a place you hadn't intended to sketch, and find the most interesting subjects!

Medium really doesn't matter that much. There is no right or wrong, and there is no magical tool. We'll look at a number of favorites: graphite, ink, colored pencil, watercolor and gouache, and we'll explore their uses and capabilities, their pros and their cons.

We'll also consider sketching with whatever is at hand, whether that's using a freebie ballpoint pen and the back of an

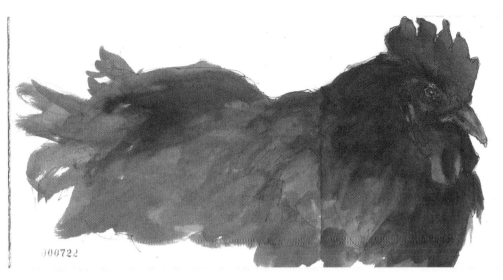

Rooster Sketch

Roz Stendahl used a full spread in her sketchbook for this rooster.

envelope, painting with the water from the lake you're sketching, or drawing with a twig you pick up off the ground. I once did a quick sketch with a piece of charcoal from a long-dead campfire that I came across in the woods.

Creating the sketch is far more important than what you use to make it. However, if you plan to sketch on the spot in a journal or sketchbook that you will close, you'll probably want to stick with a dry medium, or one that will dry completely without smearing or being sticky. The mediums previously listed are popular choices.

If you work on a board or canvas, or even a watercolor block, you may enjoy acrylics (which can make journal pages stick together even when dry) or oils. It's up to you, but the latter two will be mentioned only in passing rather than covered in depth.

In this book, we'll take ourselves sketching on the spot in deserts and deep woods, cities and small towns. We'll sketch alone, with a sketch buddy or in a crowd. We'll look at ways to decide on a subject, to simplify or to work as slowly and contemplatively as we want. Plus, we'll suggest tools and materials to make your sketching expedition a cache of lifetime memories that are both pleasurable and safe!

Come along and join us from Alaska to Australia to Asia, from the Midwest to the Middle East and points between.

Sketchbook as Journal

Most of my sketches you'll see in this book are from my journals—my favorite way to sketch on the spot. This was done with a brown ink pen and my little converted opaque watercolor set on tan paper.

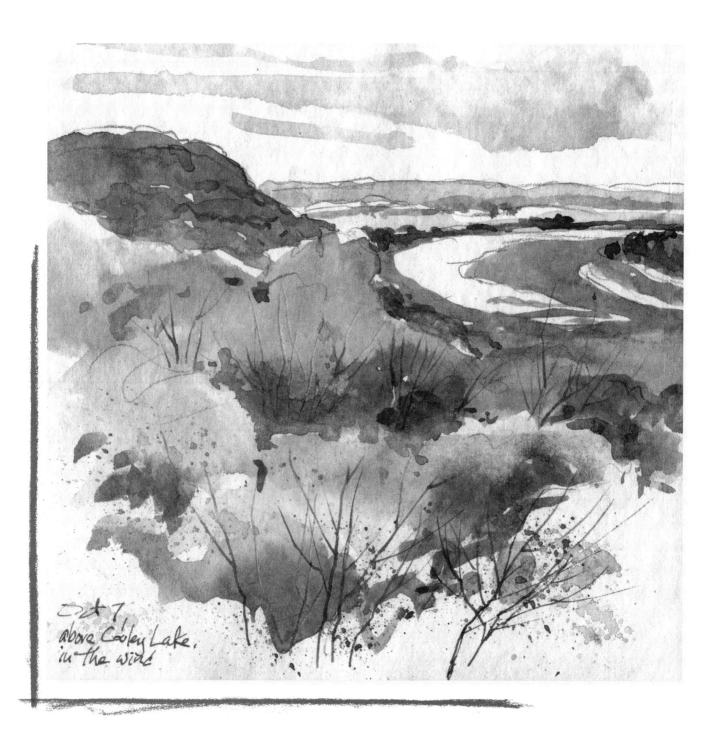

Oct 7,
above Cooley Lake,
in the wind

Getting Started

As I suggested in the introduction, sketching on the spot can be, and should be, very individual. Tweak the concept to fit your needs, and you'll find creativity everywhere. There are no rules.

Think about what it is you truly want to sketch. Do you want to explore the bustle of a busy market or a live performance? Perhaps you'd prefer something more peaceful, like a tiny mushroom by a path, or a golf course in the midst of a desert. How about an unfamiliar bird at your feeder or a beloved pet? Or maybe you'd like to get out and sketch a local art museum, a botanical garden or a fashion show?

What speaks to you? What makes you stop in your tracks and grab for your pencil or watercolors? It could be anything. Remain open to inspiration, to serendipity and to your muse. It's absolutely unique to you, even if the subject has been done countless times. Your response is what matters.

Look all around you. Lie on your back on a picnic table and look at the interlaced branches of a tree, and consider what creatures make their homes there. Perhaps you'll spot a squirrel's summer nest. Look down at your feet. What is that tiny flower? What kind of fossil is that? Draw it and identify it later! Before you know it, you may have a field guide to your own life.

Look to the horizon if there is a glorious sunset, and then, as Mary Whyte suggests in her lovely book, *An Artist's Way of Seeing*, turn around and look behind you. Maybe the subtle, less showy afterglow is what stirs a response, making your fingers itch to get it down on paper.

My first North Light book, *Painting Nature's Details in Watercolor,* focused on finding the small beauties at our feet by discovering something close by to inspire us. My husband, Joseph Ruckman, also an artist, is drawn to the grand, sweeping vista, but those are often few and far between unless you live in the mountains or by the shore.

You can always find something to paint or draw if you're looking for it, and if you're open to inspiration.

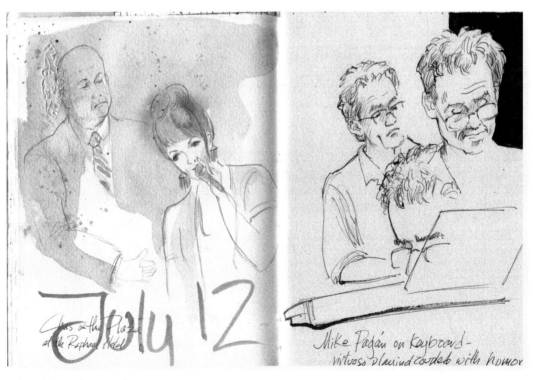

Sketching Live Performances

I enjoy sketching live performances. It's good practice, and it gives me an excuse to sit close to the music! This is our godchild, Molly Hammer, rocking it in Kansas City.

When Are You Able to Sketch on the Spot?

Well, don't wait for the trip of a lifetime! We don't even need to wait for our vacation or the weekend. Sketching opportunities are all around us. We don't have to invest a whole day, or even a whole hour; this moment is what we have.

"When" is when you make it. I keep my eyes open for bits of time while waiting for dinner at restaurants (or while I cook it), at doctors' offices (there always seems to be plenty of time to wait), on planes or in parking lots while my husband shops.

I hate shopping, so I have no shortage of parking lot sketches. Our local grocery store overlooks an open valley, a car dealership, a small state highway and a railroad track, and my journals have a dozen views of these places. It's a wonderful way to pass the time and keep the hand-eye coordination in shape with a quick-sketching technique.

Something You Love

Find one thing a day that really captures your attention. Try to pick something you love, something that touches your heart and asks a question that piques your curiosity.

Do a quick sketch, and if you have more time, develop it more fully. I almost guarantee you will feel that you truly lived during that period of time; you will remember just that moment, however brief or long.

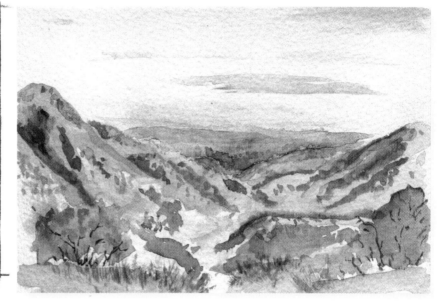

Angeles Crest

This is my husband Joseph's sketch, on the spot at the Angeles Crest Highway overlooking Los Angeles.

Flower Pots

This sketch was from my very first North Light book in 1987. The little pots on my back porch caught the winter sunlight and were warmed beautifully. I sketched quickly before my fingers froze!

Window of Time

Find a parking place that faces the most action and do some gesture sketches of people that take you no more than 5 or 10 seconds. If you can't finish one before they move on, just add the legs from another person or draw however much you can of each. These aren't portraits; it's the fun of being there and doing it that counts.

You can sketch while watching TV (though I find I have much more time to be creative since I turned mine off 17 years ago). Many artists I know sketch the actors or newscasters, animals from nature programs or their cat on their own lap as they sit in comfort. Essentially, it's a window of time that you can use however you want.

Sketch the kids at soccer or dance while you wait to ferry them from here to there, or capture your spouse cleaning the gutters—I have.

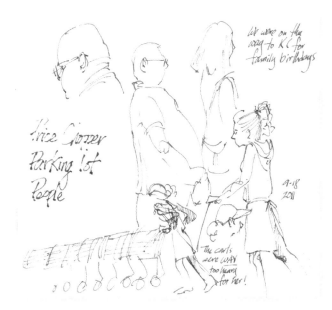

People Sketching

It's fun (and great practice) trying to capture quick gesture sketches as people walk by. My fellow shoppers offer wonderful opportunities to observe, learn and practice fast-sketching skills. I enjoy working on toned paper because you can get dimensional effects quickly, with lights and darks.

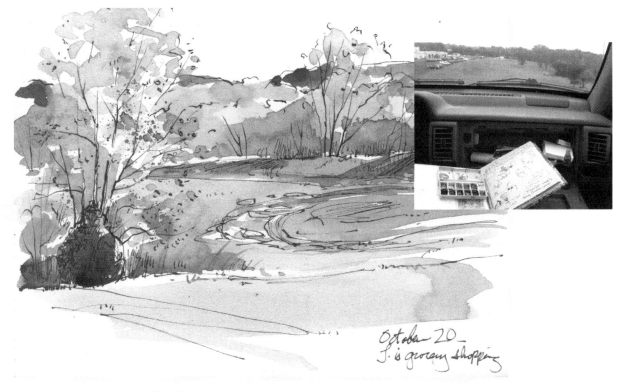

Make the Environment Work

I often find myself overlooking this field while my husband does the grocery shopping. My glove box lid made a fine sketching table as I tried out several different approaches in the time I had available. An old calligraphy pen worked well for this one, as did the watercolors I always keep in the car.

When you don't have much time, choose the simplest of materials or tools. I keep a mechanical pencil handy. It never needs sharpening, and it has its own soft, white eraser if I need it. An ink pen is often my tool of choice, and I can add color later if I wish. A single colored pencil is a great fast-sketching tool. I often use a 90% Grey Prismacolor pencil, but Indigo, Black Raspberry or even red can give you a wonderfully exciting vibration.

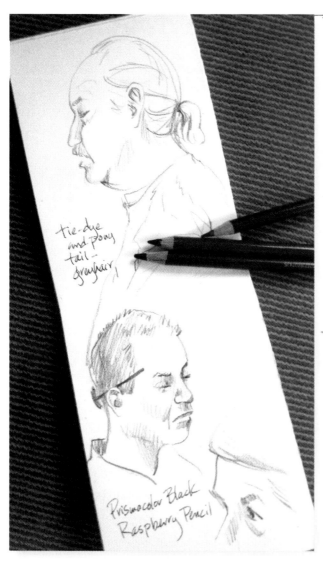

Accordion Journal

I keep a small, homemade accordion journal in my bag. The paper is left over from a more ambitious bookbinding project. It's handy for quick sketches like this; small and lightweight, it is also unobtrusive. It's also fun to use an unexpected color for sketching, like this Black Raspberry!

Be Prepared

Just like the Boy Scouts, you should always be prepared. Carry the basics with you: a small journal or sketchbook, a tiny watercolor kit, and a pencil or ink pen. I have a kit that I carry in my purse at all times, one in both vehicles, and a more complete outfit by the front door for larger works or longer trips, ready to pick up at any time as I go out.

Of course, "be prepared" doesn't just apply to when you're out and about. I like to keep the basics for sketching in various places around my house: near the couch, at my computer, in the bedroom, and even in the kitchen! You never know when something will inspire you, or when you'll have a few moments to sketch.

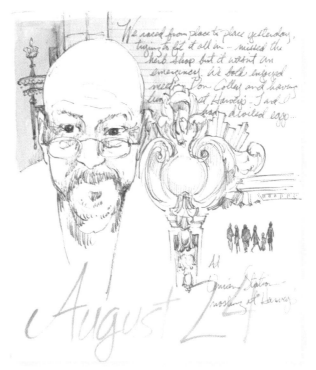

Sketch a Friend

I sketched fellow artist Don Colley with a simple, inexpensive fountain pen with a flexible nib as we visited in Kansas City's Union Station. I added color and written notes later, at home.

Set Aside Time

Set aside a special time for yourself. We all have busy lives, but if you prioritize and turn off the TV or say "no" to an obligation, you can find at least a bit of time for art.

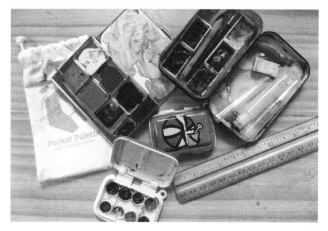

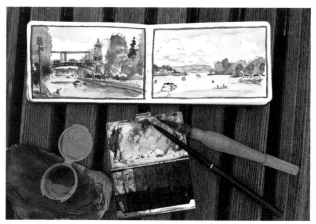

Watercolor Kits

You may feel more playful and less stressed with a small watercolor set like these, and perhaps, more encouraged to grab a quick sketch. Clockwise from top right: my homemade kit made from a candy tin; two tiny lightweight kits made from a children's set (pop out the colors and add your own artist-quality ones); and the handy Pocket Palette.

No Kit Is Too Small

Maria Coryell-Martin's kit is truly small and lightweight—it's no larger than a card case. She does amazing things with it, as you'll see later in the book!

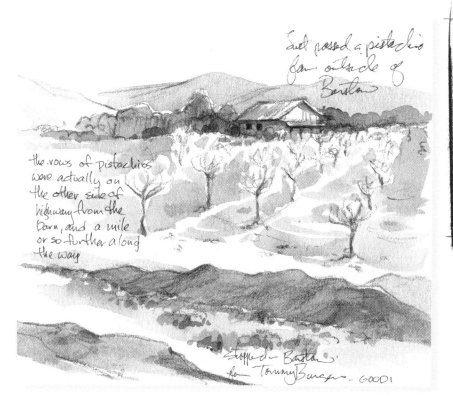

Car Sketching, California

It often works best, when time is short or you're on the move, to draw in a single medium. In this case, I drew with a dark gray wax-based colored pencil and then added color later from memory. It helps to not get hung up on trying to match the sometimes-confusing local color. The added advantage is that working in stages like this helps to train your color memory and capture the essence or mood of the scene.

Be Creative With Time

Set the alarm to get up a half hour earlier, or stay up a bit later. After the kids are in bed, you may be too tired for a tour de force worthy of framing, but not for a 10-minute sketch. Those lost bits of time do add up!

Where Do You Want to Be?

Where do you want to be or where are you, right now? Of course, you don't have to go anywhere since there is always something to sketch from life, but do ask yourself what appeals to you on this day.

I find I am much happier if I sketch something I care about; something that touches or interests me in some way.

Sometimes it takes a major effort to pick up and go. It's an expense of time, energy and money that may be in short supply. Happily, most of us have a wide range of things we enjoy sketching, some of them nearby. Luckily, my town is full of narrow, interesting alleys, old homes, architectural details and mysterious doorways, and I love to ferret them out.

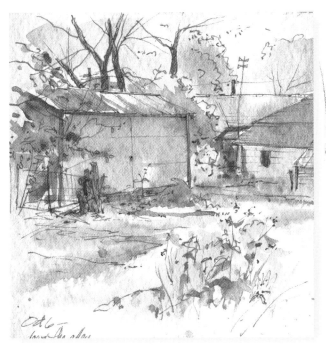

Heart Homes

I have a variety of "heart homes" or places that I have sketched again and again. Our old cabin is one of them, as is the view across the alley from my little shed/studio. The alley behind my studio doesn't go all the way through between streets, but it's a fairly busy thoroughfare for walkers! I've sketched both ends of it. This is the more populous end with my neighbor's dilapidated garage.

Inner Critic

The Inner Critic may get on your case about wasting valuable time when there are more important things to do. How do I suggest dealing with that sourpuss? Greet that fearful, judgmental, negative or angry voice with kindness, gratitude and respect. It's only trying to save you from failure, outward criticism, embarrassment or disappointment, after all.

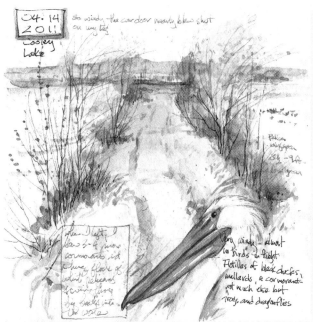

Find Your Peaceful Spot

When I need peace, I often find myself sketching at Cooley Lake, an old oxbow of the Missouri River. This year, breeding pelicans had stopped by and filled the air with their huge wingspan.

Doings in a Day

If you're really convinced you don't have any time for yourself, get hold of a tiny spiral-bound notebook and carry it with you wherever you go, just for a day. Make note of all the bits of time otherwise wasted, perhaps waiting, texting, watching TV or riding in a car—but not while driving, of course!

the alley between Mook's (now) building
and Tribal Graphics/Sign Company
Christiana & I were the only participants again this time - had a
lovely lemon fromage at Scandinavian Country, after.

Revisit Time

Perhaps there's a special fountain you love in your town, or a museum that has spoken to you through the years.

I love to sit and sketch the ancient GuanYin statue in the Nelson-Atkins Gallery of Art in Kansas City. I have been visiting this serene visage since I was very young, and I find the peace palpable. The hushed sounds, the scent of antiquity and old wood, and the dim light call to me again and again.

What have you revisited time and again? Once you know the answer, draw it.

Check the Rules

If you're working in a museum or other public place, it's a good idea to check their rules or requirements. Some museums won't let you sketch at all, others encourage it. Some, like the Nelson, welcome it but ask that you use pencil (or colored pencil) only. You wouldn't want to have your materials confiscated or find yourself escorted out the door!

Pretending

What can you find in your own area? Walk around like a tourist and pretend you've never been there before. Look up or down at your feet to find amazing mosaic work you've never noticed. Explore alleys and fire escapes if you haven't before, assuming you can do so safely. Look at the backs of buildings as well as the more familiar façades; in my town they have an almost European feel.

It's interesting to see how different artists see similar subjects. A group of us had a sketchcrawl at the Historic Elms Hotel where they're always happy to welcome artists on their grounds or in the hotel itself. We just stay out of the way of major events like weddings!

As you can see in these images, Don Gore and I were sketching on opposite ends at the back of the big historic hotel. He chose a very clean, crisp ink effect, while mine is graphite and watercolor.

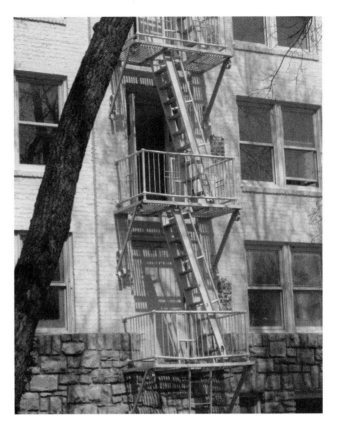

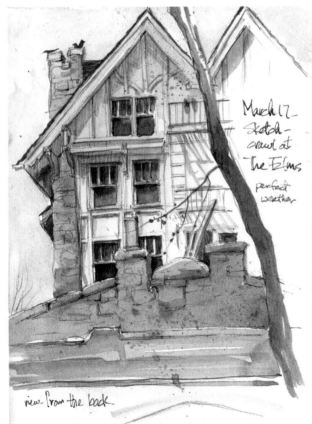

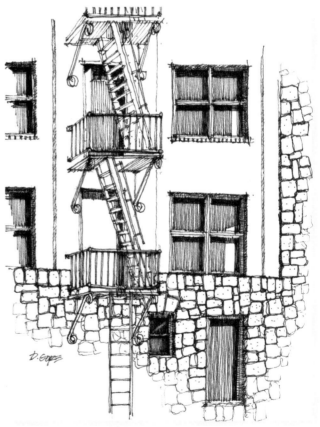

Cathy Johnson's Sketchcrawl

I chose a view from the other end of the hotel. It's still from the back, but it includes the peaks with their English-inn trim and the massive chimney.

Don Gore's Sketchcrawl

This is what Don saw. What would you have done with it?

Soul Travel

Of course, if you can, arrange to sketch in places that speak to your soul, near or far. Find a Zen garden or a small country church. You may yearn to sketch in the world's great museums. Travel to the seashore or the mountains. Maybe it's a magical botanical garden with its riot of blooming color, or a tropical island. If that's what you truly need, make it happen if you can. You're worth it!

Shevaun Doherty spent years in the desert. She sketched the people, landscapes and plants, including this date palm.

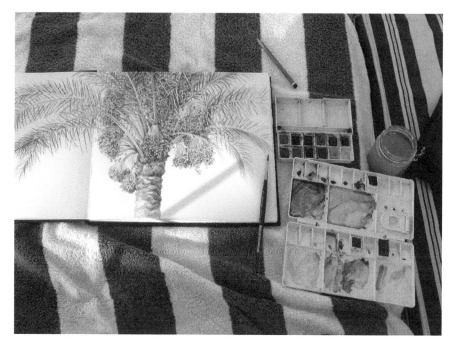

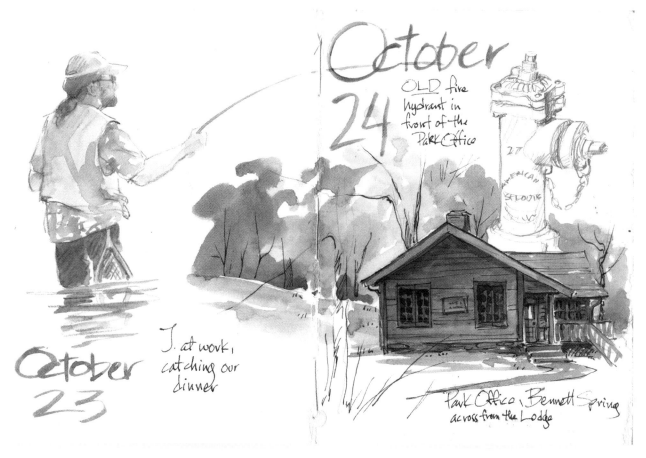

Travel With Supplies

Take your art supplies on a family vacation or a business trip, and make sure your companions know sketching is important to you. Take some time for yourself and make it your personal break or enlist a sketching partner. Draw while they shop or hit the pub, or sketch *in* the pub—that's fun too!

I enjoyed using a variety of mediums for this little two-page montage on a recent trip to the Ozarks. Watercolor pencil in blue-gray, watercolors, ink and graphite made it interesting.

The Most Important Question: Why?

What makes you happy? Why are you doing this? What is it you want to record, accomplish or learn? Only you can answer these questions. No one else can graft their answers onto your creative spirit.

My response, though, is that we do it because we *have* to. We are creative beings. It's who we are. We find joy, satisfaction and challenge in it.

Kick the Inner Critic in the figurative behind, as well as anyone else who seeks to discourage you, whether on purpose or not. Don't get too serious about it, however, and don't succumb to angst or insecurity. Just jump right in!

Find a quiet place where you won't be disturbed for a while and let your thoughts bubble to the surface. Images of things you love may arise, or dreams, or goals; things that have inspired or intrigued you. "Why" may be right there, among those thoughts.

I find it helpful to write lists when I'm feeling scattered or unfocused (or even when I'm not). It's good to make our intentions concrete sometimes, and writing them down does just that. Write whatever occurs to you! Don't edit, don't second-guess yourself, don't think "that sounds silly," or "I can't write that" or "what if so-and-so sees this?" Just write whatever pops into your mind.

You can refer back to the list later, to see how you're doing, to add to it or to subtract, if need be!

By the way, my answer to that important "why" is, as I suggested above, because it's who I am. I need to do this. It feels right. There's no big goal, no inner assignment, no plan—I just do it. Sort of like breathing.

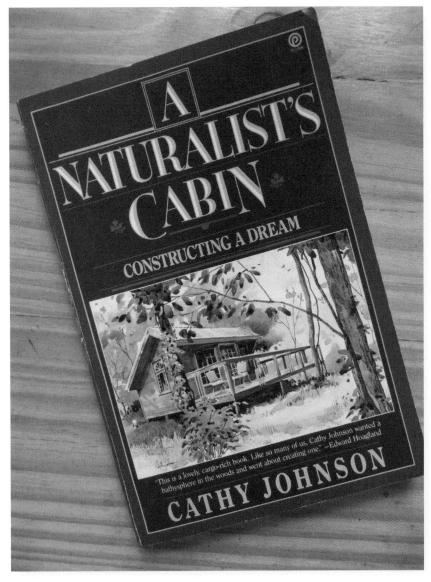

A Naturalist's Cabin

I built my cabin in the woods in the late '80s, and I have sketched and painted it many times, including for the cover of the book I wrote about the process.

Artistic License

In your journal or sketchbook, or on a separate piece of paper, make a list of any ideas that come to you after reading the inspiration on this page. Write until nothing more occurs to you.

Now give yourself permission to do whatever it is you've written down. Issue yourself an Artistic License!

Sketching What Touches Your Heart

For me, capturing my feelings for a place, immediately and on the spot, is often the most important issue. During a recent winter thaw, I enjoyed the chance to sketch one of my heart homes in watercolor.

Materials
1" (2.5cm) flat brush, no. 8 round brush, assorted watercolor pigments, graphite pencil, watercolor journal or sketchbook

1 Thumbnail Sketch
I sketched a quick thumbnail of what I envisioned the painting looking like on a small scale.

2 Create a Sketch Plan
I drew simple pencil guidelines without focusing on detail at that point.

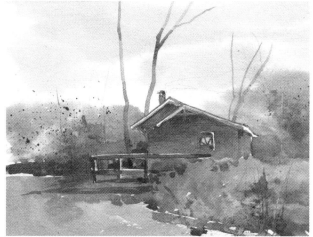

3 Apply a First Wash
I wet the sky area with clear water and dropped in sky and clouds with some variation. I suggested the distant trees while the area was still wet so they would blend softly.

I painted in the foreground grasses and brush quickly so there were some lost and found edges, as well as crisp, hard ones.

4 Create Additional Washes and Details
I used simple washes of Burnt Sienna and Ultramarine Blue for the cabin itself. I was careful to leave the light-struck areas of the railing, the window and the edge of the roof as white paper. I added a bit of spatter to give the image texture and interest, then let the painting dry. Once everything was dry, I painted in the first simple tree shapes.

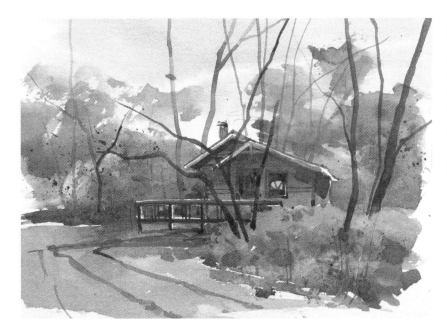

5 Drybrush Details

I added drybrush tree foliage in the background, more tree shapes (cooler and simpler for the ones farther back), and added detail to the cabin. I addressed the window, door trim and roof edge, and suggested the siding.

6 Apply Final Touches

Finally, I added more trees and crisp touches of brown ink and a bit of gouache for colorful leaves.

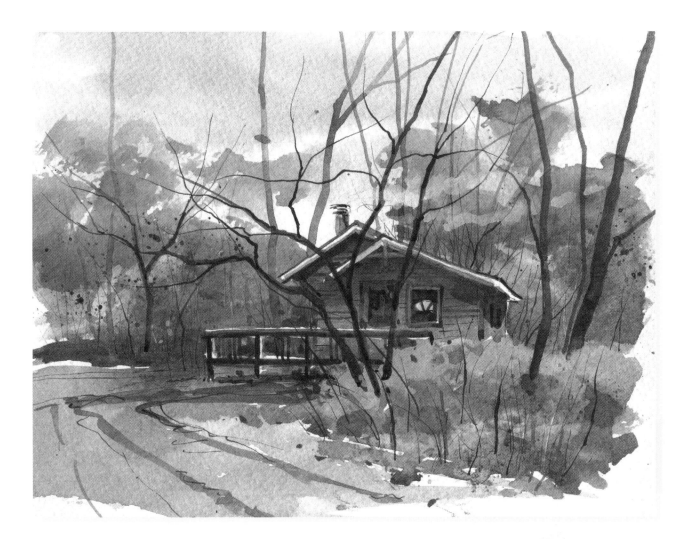

Sketchbook, Journal, Finished Work?

So what's the difference between a sketchbook and a journal? The answer to that is personal preference. For me, sketchbooks and journals have been fairly interchangeable. But a sketchbook often feels more casual and less intensely personal. It's a place to plan, to capture a moment or complete a study for a larger work. But I have done all those things in my journal, as well.

If that's what you're in the mood for, grab a spiral-bound sketchbook or a tablet and jump right in.

Your personal journal can be whatever you make it. It can contain sketches, drawings, finished paintings, images captured while traveling, ideas for your garden, and designs for a new quilt or room re-do. It may also contain written entries: notes, musings, quotes you like, poetry, grocery lists or phone numbers. It's your journal, so put in it what you like.

Working on the spot often provides a great deal of sensory input, and making note of those things can bring your sketches to life. Maybe you overhear a bit of interesting conversation or a funny story as you sketch. Perhaps you experience a rush of joy, or hear a bit of music that seems to fit perfectly with what you're drawing. Write it down and it will stay with you as long as your journal does!

Now that you're armed with personal intent, and you're ready to carve out the time you need, we'll look at the materials and supplies you may find essential. Some may be old standbys, others may be brand new to you. I often grow by trying something new, even if it's outside my comfort zone. You may want to experiment with these in the course of working through this book. Who knows where you'll end up?

Steve Penberthy
Watercolor Sketch

Sketching on the spot often results in a finished work, a plein air painting or a drawing that you may want to frame, so you may not want to have too many written notes on the page unless you are making color notes or thumbnail value sketches.

Cathy Johnson
Watercolor Beach Sketch

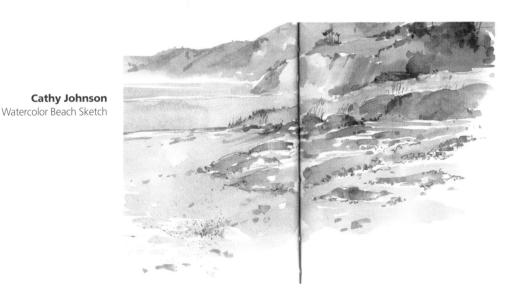

21

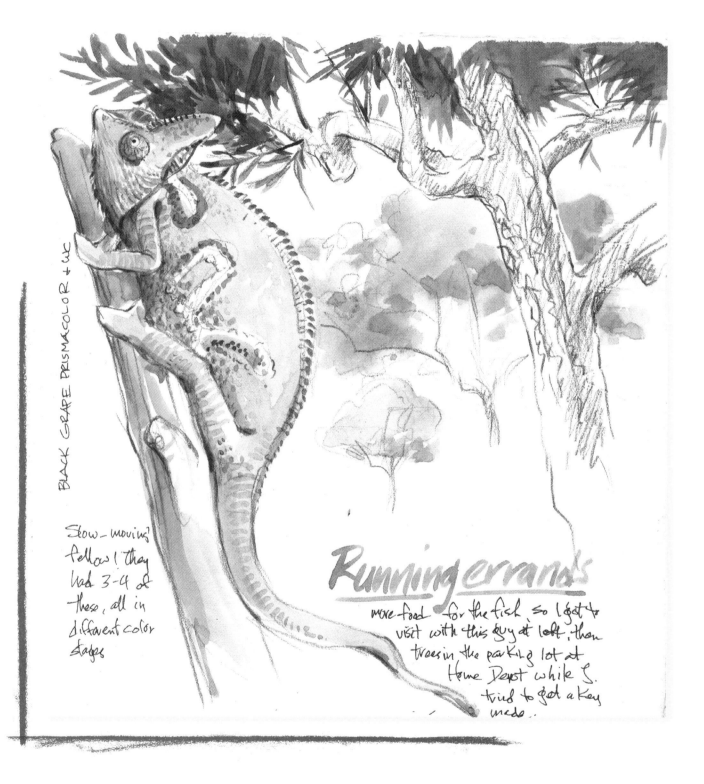

BLACK GRAPE PRISMACOLOR & W.C.

Slow-moving?
fellow! they
had 3-4 of
these, all in
different color
stages

Running errands

more food for the fish so I got to
visit with this guy at left, then
trees in the parking lot at
Home Depot while S.
tried to get a key
made.

Materials and Supplies

All you really need for sketching is something to draw on and something to draw with. For many years, I filled journal after journal using only a technical pen for both writing and drawing, supplemented on occasion with a wax-based colored pencil in a dark value. (Warm or cool dark gray, black, Black Raspberry and Indigo are still my favorites.)

Eventually, I needed more color and added a few more colored pencils to my small set. Then I realized I wanted to add watercolor to my sketch journal. By then, I was painting a great deal and watercolor *is* my first love, but the paper in my inexpensive commercial journal was unsuited to the medium.

It was soft and too absorbent, and the colors were dulled, so the search for a good journal or sketchbook was on!

Choosing the right materials and supplies to best fit your needs may seem daunting. The key is to keep it simple and use what you have—ink, pencil, colored pencil, watercolor pencil or watercolor markers—whatever you want. It's even okay to use a set of kids' crayons if you like. Just explore and have fun.

There is no magic tool, no magic brush, no magic pencil. It's all about what *you* choose to do with them, so try them all or mix them up if you like. Let nothing get in the way of seeing, enjoying, creating and learning.

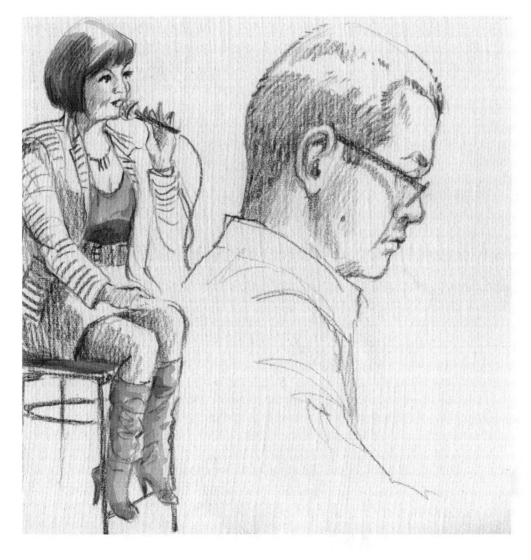

Adding Color
Sometimes I add color to my single-pencil sketch, sometimes I don't. I was taken by Molly's turquoise boots and red hair, so I used a combination effect with Black Raspberry pencil on Frankfurt paper.

Paper Trail

Sketching is just as much about the paper as it is about the drawing utensils that you use. Do you want watercolor paper, drawing paper, a bit of "tooth" or texture? Super-smooth paper that will work well with ink or graphite? Bright white paper so your color will sparkle? Creamy ivory for a rich, vintage look?

What about a brown-paper-bag color or a medium gray that will allow an almost 3-D effect if you work with light and dark ink or pencil? Sometimes I even use black paper and draw on it with colored pencils in lighter values.

Toned Paper

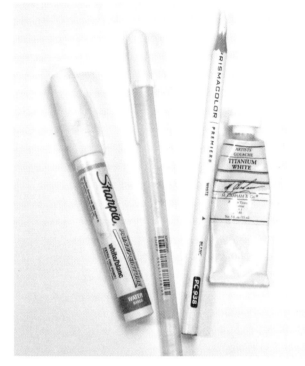

Get the Sparkle Effect

Gel pens, acrylic markers and colored pencils are just a few of the tools you can use to get that sparkle of white on black or toned paper. Of course, when you're working on white or light-toned paper, the paper itself acts as your lightest lights.

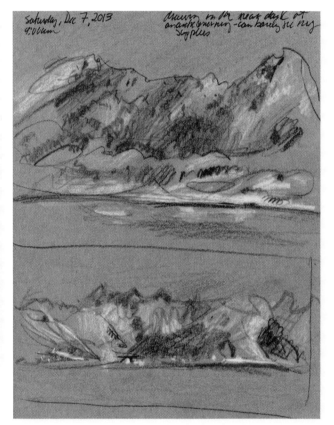

Luminous Chill

Use toned paper to capture a mood or temperature, as Laura Murphy Frankstone did. To capture Norway's luminous chill, she used a few judiciously chosen colors to create that feeling, in addition to black and white.

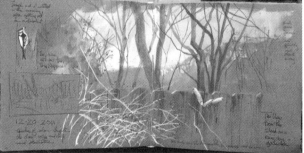

Varied Colors

A small set of opaque watercolors (look for gouache paints) lets you work on all kinds and colors of paper, like this mid-toned brown.

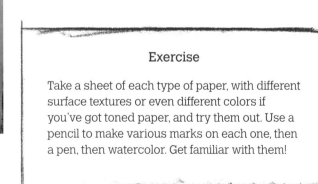

Exercise

Take a sheet of each type of paper, with different surface textures or even different colors if you've got toned paper, and try them out. Use a pencil to make various marks on each one, then a pen, then watercolor. Get familiar with them!

Formats

There are a lot of format choices: spiral, ring-bound, hardbound or accordion, for instance.

You might like spiral-bound books because they open flat and fold back on themselves to give you a bit of extra support to work on. On the other hand, the spiral may get in the way of your drawing hand when the sketchbook is laid out flat.

Ring-bound books are handy (and easy to come by), but I still find my favorite is a hardbound sketchbook or journal that will stand up to a lot of abuse.

Paper finish and surface makes a difference, too. You may choose hot-pressed (smooth), cold-pressed or rough. Paper may have sizing or other finishes that may be both internally and externally applied. (In some cases, like Japanese rice papers, there is no sizing, or almost none.) Sizing gives paper a harder surface that makes it tough and able to withstand more aggressive watercolor techniques like scraping or lifting.

I prefer a paper with fairly heavy sizing, because my pencil and pen seem to glide more easily. Also, paint stays more on the surface rather than being absorbed, which can give your work more sparkle.

Assorted Formats
Size, format and surface texture are all very personal choices.

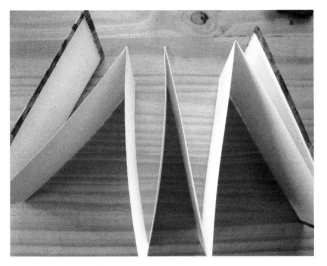

Accordion Books
Accordion books like this let you combine images from one page to the next for continuity, and it allows you to work on both sides. They're great for themed books.

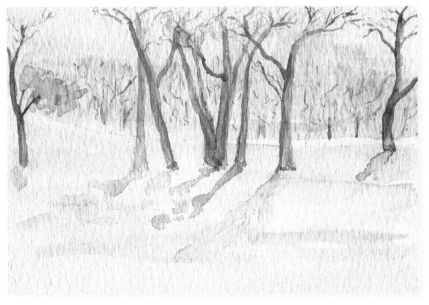

Small Sizes
My husband and favorite painting partner, Joseph, prefers the smallest spiral pad he can slip into his cargo pants pocket, along with a tiny watercolor set. The largest he works is on a 5" × 7" (13cm × 18cm) watercolor block, like the image here. This size is lightweight, handy and unobtrusive.

Other Surfaces

You may be painting in acrylic or oils, and you might like canvas, canvas board or even sketchbooks of bound canvas (or canvas-textured paper). There are also a variety of hard-surface painting boards, as well as watercolor paper already mounted to board. These are handy in the field but are heavier to carry. A canvas pad or canvas-textured paper can be fun to sketch on, as it offers interesting textural effects.

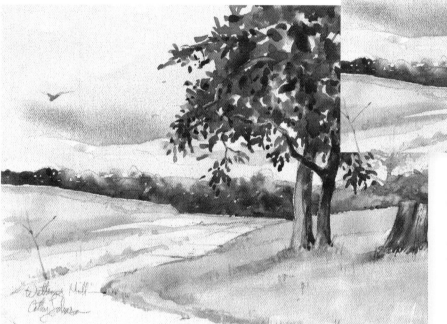

See the Texture
You can really see the texture of the canvas pad in this pencil and watercolor detail of my sketch at Watkins Mill. The texture helps capture the feeling of the rainy day.

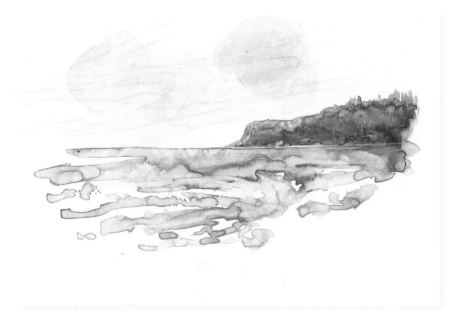

Yupo Paper
Many watercolorists are experimenting with Yupo "paper," which is really a thin plastic prepared for painting. It doesn't buckle under a wet wash, but because it's completely nonabsorbent, your paint (or other medium like ink or graphite) sits on top. It can make interesting puddles and can be lifted and manipulated easily. It's fun, though challenging.

Pencils

Pencils are the simplest tools you can use, and they're surprisingly versatile. They're easy to find, too! Most art or office supply, craft, grocery or discount store will have a few pencils to choose from. A no. 2 office pencil is a fine sketching tool.

Some artists prefer to work with a variety of hardnesses for different effects. To keep it simple, I usually choose an HB, which is a mid-range, or a B or 2B, both of which are a bit softer. You can get a huge range of values with these, depending on how hard you press.

My preference for on-the-spot sketching is a 0.5 or 0.7mm mechanical pencil with a soft white eraser on the end in case I want to erase or adjust values.

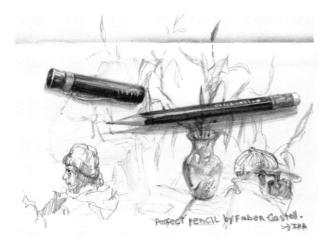

Pencil Range
Nik Ira masterfully explored the range of a single pencil and then drew the pencil right on her journal page.

Pencil Lines
Lightweight and easy to use, graphite pencil worked perfectly for this bird, one of Roz Stendahl's favorite subjects. It shows plenty of detail and a wide range of values.

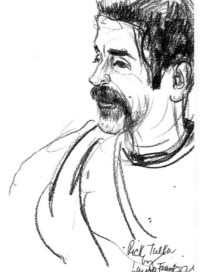

RICK TULKA

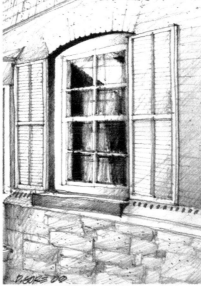

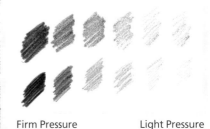

Firm Pressure Light Pressure

Pencil Strokes
Laura Murphy Frankstone uses sure strokes with a soft, dark pencil for a bold effect in this sketch of fellow artist Rick Tulka.

Pencil Values
Kansas City artist Don Gore demonstrates a wonderful range of values with a single pencil.

Exercise

Make marks and areas of flat tone with each of your pencils. Try the tip, the side—whatever. Become familiar with what you can expect from them, and you'll know which to grab in a hurry.

Colored Pencils

A small handful of colored pencils are great for adding a bit of life to a sketch. As mentioned previously, I often sketch with a single pencil in a dark color (or an interesting one) and then either add watercolor or let it stand as is.

Because colored pencils are a dry medium, they're simpler and more immediate than some other materials. There's no need to carry brushes or water into the field, and once you put down the color, you're done. You can normally use them in museums where wet media are prohibited, as well.

Cases make carrying several colored pencils in the field easy (while protecting their points), but you can also just bundle a handful of them together with a rubber band. If you're trying to keep it light and simple, that's a good option.

You can choose from traditional wax-based pencils or the newer oil-based pencils. I would suggest buying a similar color of each type from open stock to try them out. Wax-based pencils generally won't lift or smear under watercolor washes and, therefore, are one of my favorite tools. Oil-based pencils may be harder and drier, and they smear more easily.

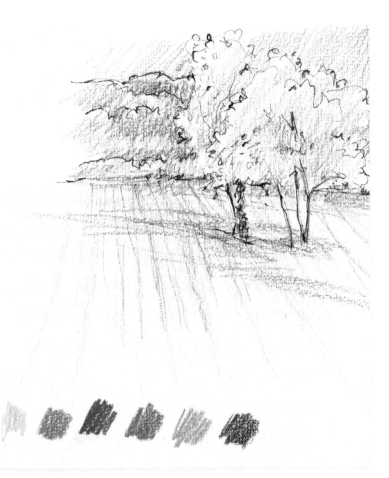

Pencil Bundles

For easy maneuvering, bundle your pencils up with a rubber band, as Joseph did here.

Exercise

Try a simple ink framework for a landscape, then add color using only a few colored pencils. Layer for more complex colors.

Colored Pencils and Ink

I like to simplify my kit for on-the-spot work. Having only the primary colors and a few supplemental pencils works just fine. The combination of colored pencils and ink is a happy one.

Unusual Color

As noted, one of my favorite combinations for sketching on the spot is a dark wax-based colored pencil and watercolor. Sometimes an unusual color (rather than black, dark brown or dark gray) offers a livelier effect. In this case, I chose Indigo.

Materials
½" (1.25cm) flat brush, small bristle brush, assorted watercolor pigments, Indigo colored pencil, watercolor paper or journal

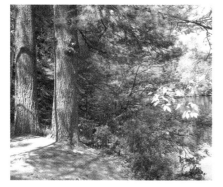

1 Identify the Image
The trees beside our campsite at Fish Creek Pond caught my eye.

2 Create a Sketch Plan
I used an Indigo wax-based colored pencil to lay in the underlying sketch.

3 Apply a First Wash
I added the first light colors using waterbrushes and watercolors.

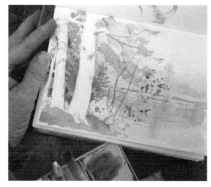

4 Apply a Second Wash
When the first washes are dry, I added stronger values and brighter colors.

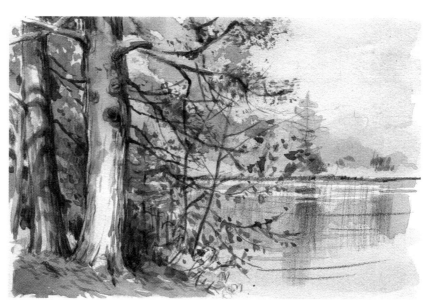

5 Apply Final Touches
I used a small bristle brush and jabbing strokes to suggest the lacy pine tree overhanging the lake.

Watercolor Pencils

A few watercolor pencils and a waterbrush make for a lightweight sketch kit. I've made up a small, customized set from open stock, choosing colors that are the most lightfast.

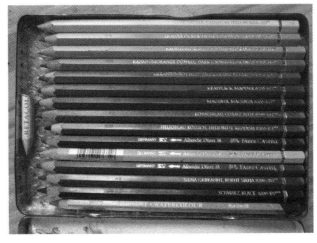

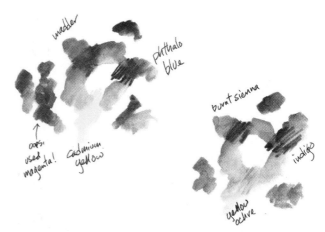

Assorted Pencils

Choose a triad of primaries, either bright or subdued, for outdoor sketching. You could also carry a single pencil for drawing and blend with water for halftone values.

Experiment

I've experimented a lot with simplifying what I carry with me. Here are two possible triads that are very versatile.

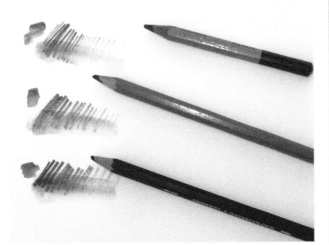

Derwent Blue Gray

Derwent has changed the formulation for my beloved Blue Gray 68, and it's too soft and emphatic for my purposes now. So be aware that even favorite products can change! From top to bottom: The stub of an old pencil, the pencil I've used most and the current pencil.

Color Choices

Take a peek at Kolby Kirk's brilliant solution: a set of cut-off watercolor pencils and box all in one! It only weighs 6 oz. but gives him a lot of color choices. He uses the leads of the pencils like tiny watercolor pans.

Ink Pens and Markers

Many artists like to draw on the spot with ink, either alone or in combination with watercolor or colored pencils. They may sketch in guidelines with pencil first, as Liz Steel sometimes does, or jump right in, like Warren Ludwig. They may do the ink drawing first and then add color, like Don Low, or include touches of ink to add sparkle to a watercolor sketch. There is no "right" way to work, just as there is no perfect pen. Again, it's a very personal decision.

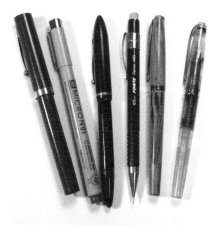

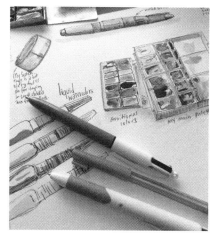

Pens

These are some of the pens (and a favorite pencil) that I use frequently. From left: A Sheaffer calligraphy pen I've had for decades, a Micron Pigma disposable, an ancient Sheaffer fountain pen from the 1920s, a mechanical pencil I've had for decades and two new Noodler's Creaper flex pens.

Markers

Markers are handy tools for working on the spot, and they come in many styles, including double-ended markers, calligraphy markers and brush-tip markers. You can get them in a wide range of colors, too, and many are water-soluble so they can double as watercolor-like tools.

Combinations

The combination of ink and watercolor is a happy one, and sketches done in ink alone are often clean, crisp and powerful. Don't be put off by the emphatic quality of ink if you draw a line you don't like; just draw another right beside it. Sometimes that creates a wonderful vibration, a story of the creative process. "Perfection" need not apply—we're sketching here!

There are several brands out there that carry felt tip, ballpoint or fountain pens. Some are waterproof and some are water-soluble, so be sure to test in an unobtrusive spot before surprising yourself in the field. A disposable, water-soluble pen will allow you to wet the lines and add value.

You may prefer a refillable fountain pen you can keep for a long time. In that case, try either water-resistant ink that won't smear and will retain sharp lines, or water-soluble ink that will lift with the touch of a brush, letting you make interesting halftones quickly.

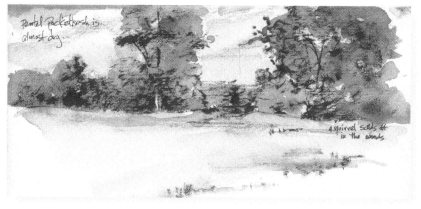

Dry Markers

Don't throw away a marker that's beginning to get a bit dry. These can provide interesting effects on textured paper.

Exercise

Try out all the pens and markers you have on one sheet of paper. It helps to make notes as well, so you remember which does what and how they feel to you. That's how I settle on my must-have tools.

Watercolors, Brushes and Extras

As noted, there is no perfect pigment (or brand), no magic must-have brush. Again, it's really a matter of personal taste, what you're comfortable with and, yes, what you can afford. Of course, we all love to experiment, and we're all inspired by other artists. I've tried lots of tools and pigments recommended by my artist friends. Some I still use, and some just weren't for me.

Watercolors and Palette

Don't worry about having every color in the rainbow and more. Learning to mix the colors you want is part of the fun, and a huge part of learning, period. You can get by with a warm and a cool of each primary color, or just one of each if you choose well.

Do use decent paints rather than those meant for kids; if cost is an issue, buy just the primaries and, perhaps, a few convenient colors. I usually add Burnt Sienna and Payne's Grey, then mix my own colors. It's fun!

Remember, if you choose watercolor for your regular sketching medium, you'll need some sort of palette or box to carry your pigments and tools in. I've used a lightweight folding plastic palette for years.

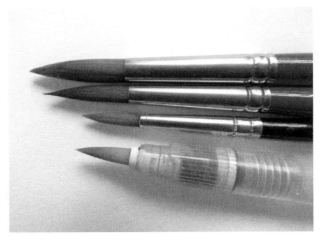

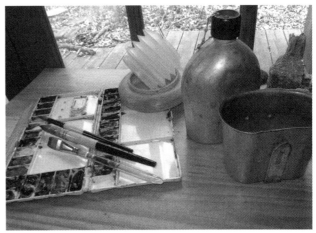

Brushes

There are many brands and sizes of watercolor brushes, both round and flat. Waterbrushes, however, come only in small, medium and large. As far as I know, there is only one company, Niji, that makes flat waterbrushes. I find them very useful in some circumstances. You'll see them at use in this book.

Extras

There are extras you may need: Water containers, tissues, erasers, pencil sharpeners and so forth. Remember, keep it light and simple and you'll be in good shape for working on the spot. You may want to weigh your supplies and make sure everything is in good working order before setting out. I hate going out to sketch only to find my fountain pen is empty when I get to my destination.

Kits

What sounds good to you? Field bag, backpack, purse, cigar box, pocket, pochade box, station wagon, camper, ghillie, Sherpa? Just kidding!

For the most part, you'll want to travel light. Complex preparations or mediums and heavy gear can get in the way of enjoyment, as well as cut into your time. Keep it simple!

There are any number of art bags, pencil cases, field bags, totes and more, specifically designed for artists on the go, and I've tried several of them. I have a lightweight ripstop nylon messenger bag I bought over a decade ago that works just fine for me. I'm continually simplifying and lightening my kit, and this has everything I need in it.

Some artists also need a sturdy stool or folding chair, an umbrella to ward off rain and sun, and even an easel. At my age, I usually keep it fairly light and simple. That means less time setting up and taking down, too, and thus more time for sketching. There have been times when bad weather threatened or things got too crowded, and I was glad I could pack up quickly and leave.

You'll see a variety of kits from the artists in this book, but preparation comes in other forms, too. Attitude, expectations, approach, goals and flexibility all enter into the equation when you're working on the spot. Remember to have fun and take what you need with you. That includes water to drink, insect repellent, a sun hat and another layer of clothes if you think the temperature may drop. Most importantly, be aware of your surroundings! For instance, in bear country you should always stay alert. (The same with large cities, too!)

Working on the spot, with changing light and weather, is a challenge, make no mistake. That's where the need to be flexible comes in. Sketching on the go is great fun right along with the challenge, and I hope you enjoy it as much as I do.

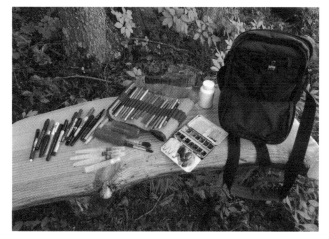

Single Bag
Jan Blencowe gets everything she needs into a single bag for easy carrying.

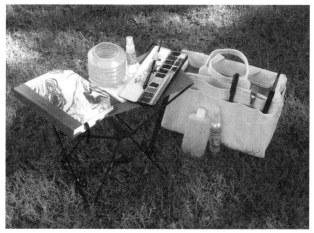

Stool and More
Depending on where she's going and what she's taking, Vicky Williamson's kit varies. From the tote, stool and other supplies seen here, there are very few things that won't fit in her bag.

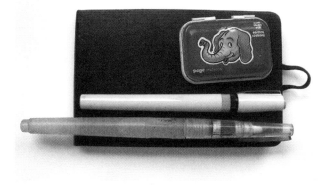

Pocket Kit
Author, artist and world traveler Danny Gregory can get his smallest sketch kit in his pocket!

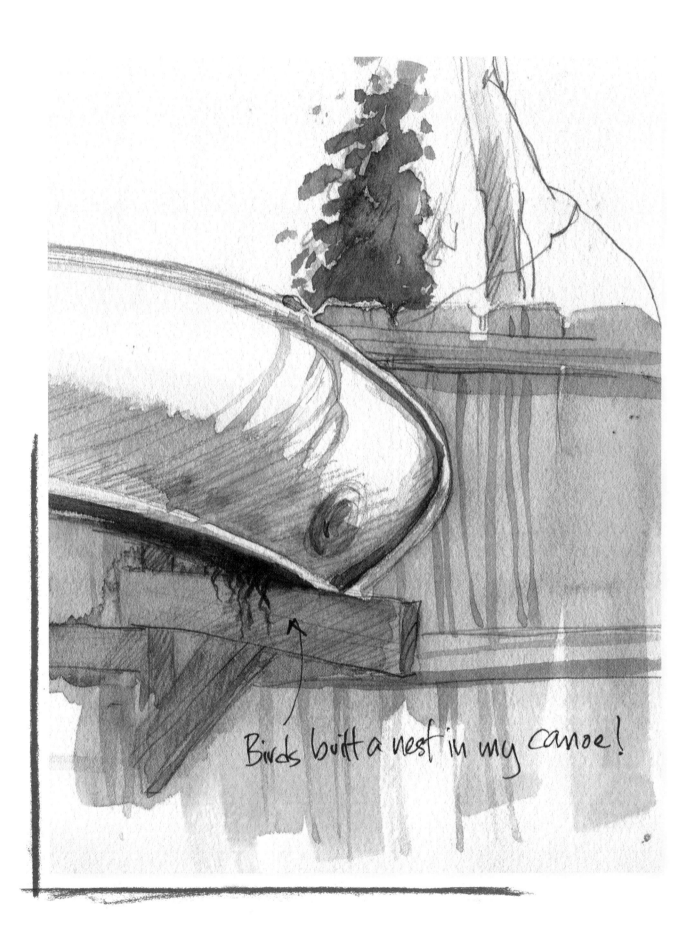

Birds built a nest in my canoe!

Exploring Your Own Backyard

Many people seem to feel they need to go somewhere exotic to sketch: a grand vista, the mountains, the ocean, foreign climes or exotic islands. If I waited for the trip of a lifetime to get out and sketch, I'd still be sitting here! The world is full of inspiration, even right on our doorstep.

Consider the way the light hits the trees on the far hill, the sparkle of sunlight on an icicle on your porch, your old dog lolling in the sun, or your child playing in a sandbox or napping on a blanket. How about a strange new wildflower that appeared in your fencerow for the first time, or an unfamiliar mushroom that sprouted after recent rain? What's that strange pod you

found in the park, and what bird dropped that gorgeous feather? What's going on in the neighbor's garden down the street, and what kind of architecture is that house on the next block?

My very first art how-to book was called *Painting Nature's Details in Watercolor*, and many of the people who read that book or attended my later workshops told me their eyes were opened to painting subjects all around them. They said they'd never again be bored or think there was nothing worth painting. I hope you'll feel that's the case now, as well. Painting on the spot doesn't have to mean travel!

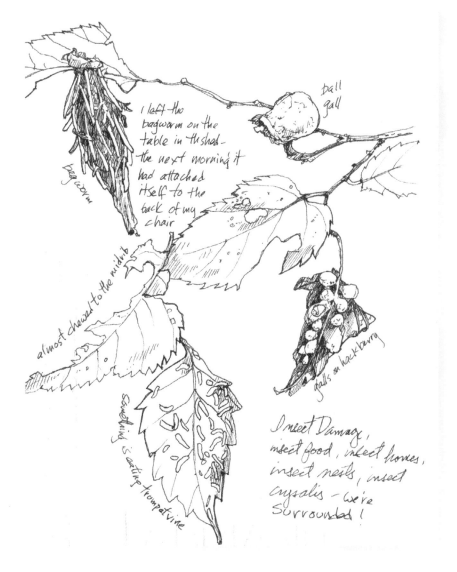

ball gall

I left the bagworm on the table in the shed—the next morning it had attached itself to the back of my chair

bagworm

almost chewed to the midrib

galls on hackberry

Insect Damage, insect food, insect homes, insect nests, insect crysalis — we're surrounded!

something is eating trumpet vine

Short Study

I noticed all of these various traces of tiny life going on all around me—a real record of our shared environment. When doing a study of this sort, I often prefer a fine-line ink pen. It's crisp and descriptive, and it lets me really catch the detail.

Open Your Eyes

Sometimes we think we must find a "worthy subject" before we draw, but almost everything fits that bill if we look at it with new eyes. Babies view the world with this kind of wonder and curiosity, so it helps to borrow a page from their baby book! Colors, textures, the way the light hits a familiar object—all those things can catch our attention and make us want to sketch.

Have you ever caught a glimpse of something out of the corner of your eye and realized you'd never noticed it before? Sometimes it's an interesting, weathered surface you overlooked. Sometimes it's the way light falls on leaves, turning them to stained glass or glistening off their surfaces, that makes make your fingers itch to draw before the scene changes.

Your garden sprouts new young plants, and you celebrate the turning seasons in your sketchbook. There's a new coffee shop in town or a spectacular show at your local museum. You read an article about your town's history and, suddenly, that funky old building you pass every day becomes wildly interesting; you want to capture its story. A bird builds its nest in your canoe or in a hanging plant on your front porch. You pick weed seeds off your jeans and discover a variety of shapes that you can't wait to sketch and identify.

These are just a few of the things you'll see around if you if you open your eyes and view your surroundings with renewed sight.

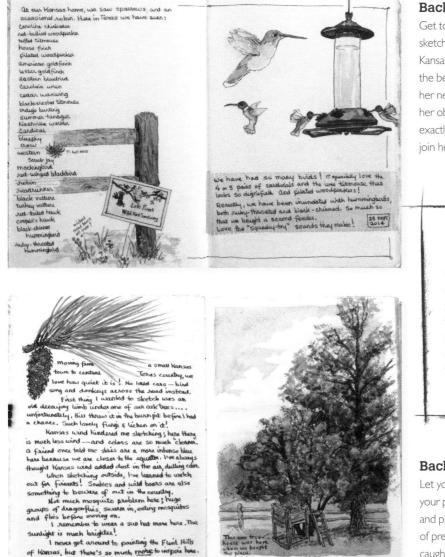

Backyard Birds

Get to know your neighborhood through your sketches, as Vicky Williamson does. Formerly of Kansas, she now lives in rural Texas and captures the beauty and variety of life as she discovers her new home. Vicky adds written notes to her observations, fleshing them out so we feel exactly where she is on the planet and want to join her there!

Exercise

Open your eyes. Be aware of everything around you. Be mindful. There are plenty of things to sketch! If you want to, get out a magnifying glass, or even a microscope. Discover the wonders all around you.

Backyard Treehouse

Let your rambles teach you something about your place on Earth. Look not only at the wildlife and plant life that surrounds you, but for signs of previous residents. Here, an old treehouse caught Vicky's attention.

Pretend You're a Tourist

One thing that may help you find exciting subjects when sketching in familiar territory is to pretend you're a tourist. Walk or ride a bike instead of zipping through in a car. Take your time and carry your sketching gear so you're always ready.

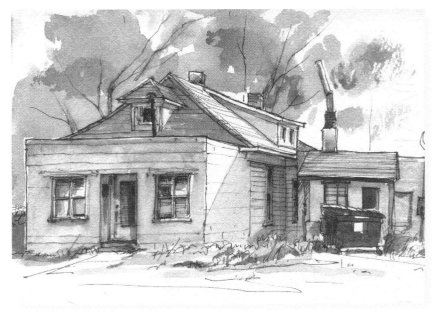

Old Stomping Grounds

When I was in third grade, I had my first taste of working with clay in this building. Recently, I went back to sketch the little building where I fell in love, only to find, to my delight, that it had hardly changed a bit!

Exercise

Imagine returning to a beloved place and sketch what you see there. Or better yet, actually do that. I recently went back to my hometown to sketch a few of the things I remembered fondly. As I drew, it brought back more than I would have imagined possible. I re-experienced not only the sights, but sounds, tastes and even conversations I thought I had forgotten.

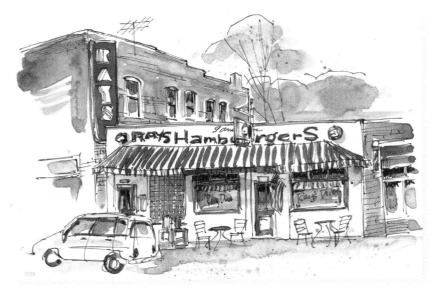

Quirky and Nostalgic

I sketched this little place rapidly, before the skies opened and dumped rain on all of us! This restaurant has been in business for 75 years and was recently rehabbed in a cozy 1950s style. They still use the same grill, though!

Change Your Point of View

Look up! Often, the tops of buildings still have their ornate 19th-century decorations or complex brickwork. Windows may be a lovely shape, or made of stained or leaded glass. You may discover a door leading to nowhere—what a mystery that is!

Look down at your feet. Is there some marvelous mosaic you've overlooked a hundred times? A new wildflower blooming in the local park, or a strange bird? Can you see tracks in the mud and figure out the story written there?

It pays to change your point of view. Once, I laid on my back on a picnic table and discovered a whole new perspective to draw from as the trees reached for light overhead. Also check the backs of familiar buildings. In my town, they tend to have a charming European feel.

If you feel more comfortable, set yourself up in your car to sketch in safety and convenience—that's what I did, below. My glove box door makes a dandy mini art desk.

Mystery Doors

I was minding the store at an art show in my town and listening to my buddy Kevin play some tunes. So, how could I fail to see and sketch this mysterious door on the second floor across the street! Toned paper made it especially interesting to me.

Modern vs. Old Architecture

The buildings in downtown Liberty sometimes have a split personality! The street level may have been modernized—and almost all have changed from their original purpose many times over—but the second floor is a time capsule of ornate brickwork and ornamentation.

too many nothing was working quite right today—pen, paper, pencil and paint, all had a mind of their own.

A bit of Liberty's square March 5, 2012

38

Explore New Places

If you're like most of us, you're likely to take the same route to and from work, the store and the library. Instead, take a different route. Check out a map of your town and look at all the places you've never seen before. Ask the local librarian what's of interest nearby; ask friends about their favorite restaurants; or go by the local historical museum and check out their archives. See if you can match up the old photos with current buildings, then sketch them.

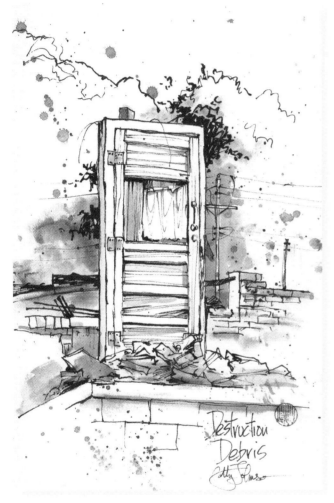

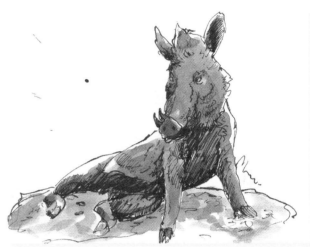

Copy Statues

This popular guy on the Plaza in Kansas City is a copy of a statue by Benelli, in Florence, Italy. People are encouraged to rub the statue's nose and make a wish—that's why that part of the boar is so shiny! Coins from the fountain are given to the Children of Mercy Hospital.

Construction Zones

The old laundry in my town was being torn down and only the door was still upright. I used a bent-nib calligraphy pen with black ink to capture the destruction. I added a bit of diluted ink to make it stand out from the background.

Exercise

Sometimes we take familiar things for granted to the point where we don't even see them. Here's an antidote that can be a lot of fun: Invite a friend from out of town to join you on a walking tour. Bring your sketchbooks and art tools, and let your buddy pick where to stop and sketch! You may be amazed at what they pick.

Do the same thing with children. Kids have a completely different outlook, unjaded and fresh. They may also see things from a lower vantage point that you may have overlooked.

Preserving Things Before They're Gone

Have you ever realized how many places and things may be endangered by age, vandalism or even progress? I have sketches of all kinds of things that aren't there any more, and I'm glad I took time to sketch them.

I also, all too often, drive by a place I've meant to sketch a dozen times and find it's being demolished, has burned down or has been so badly "remuddled" that it has no character left. A lovely little house with an alpine feel disappeared to make way for a new highway access before I ever got around to sketching it.

Perhaps, in your town, a road now goes through a favorite local wild place. A charming old bridge is replaced by a much safer one with absolutely no character at all. Barns fall in on themselves. Old garages built for Model Ts are torn down to make room for modern carports.

So take that time! Stop and sketch what moves you or what catches your eye—before it's too late!

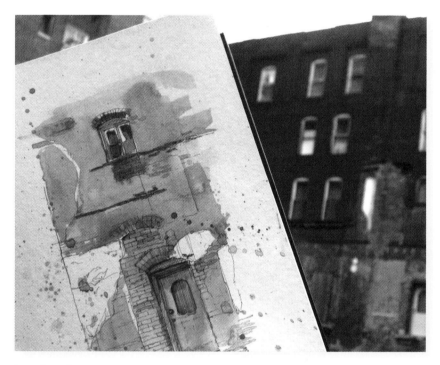

Landmarks

This old hotel has been hanging by a thread for decades. Twice, now, it has looked as if some-one would save it and make it into something brand new. Both times financing or city approval fell through at the last minute. So here it stands, one side looking for its lost hallways. I used a vignette effect and spatter to suggest the feeling of age and limbo faced by this landmark hotel. I have actually stayed in the old place, once when a blizzard kept us from our farm, so it does feel like an abandoned home.

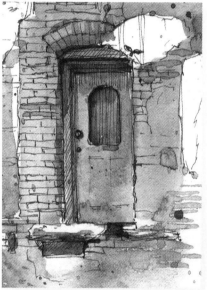

Detail 1

You can convey a feeling of spontaneity by allowing one color to flow into another. A granulating color of Burnt Sienna and Manganese Blue Hue attribute to the feeling of age here.

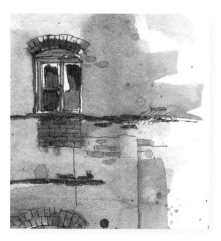

Detail 2

I simplified a great deal and used wet-in-wet, glazes and spatter to complete the look of decay.

Recording Change

Sometimes change is for the good. One of our old historic hotels, The Oaks, had been empty for years. Kids nearly burned it down setting a fire in some of the upper rooms. Trees sprouted in the basement, which was prone to flooding, and protruded from cracks in the walls and broken windows. They made a hanging garden on the outside of the building.

Mind you, that made an interesting sketch, too! But we were all glad when someone bought the beautiful old relic, cleaned it up, gutted the inside and built fresh, clean apartments. They restored and reclaimed the exterior beauty it had in the early 20th century. The basement is now a community gathering place. This place was a great save, and one I've sketched in many stages!

When a historic bridge in our town was being replaced, I was afraid it would be modern and ugly, so I recorded stages of the demolition and restoration. I sat on the gravel bank in all kinds of weather, sketching heavy machinery, workmen and crumbling chunks of cement. Happily, it's as lovely as it ever was and still greets visitors to our downtown area. (I'm so happy to be wrong sometimes!)

Try a new approach when you're exploring your own backyard—a new tool or medium—just to shake things up and let you see in new ways. I used an antique Japanese *yatate* and a bamboo stick on my bridge sketches, and they had very different effects. The bold lines seemed to capture my anxiety about the project.

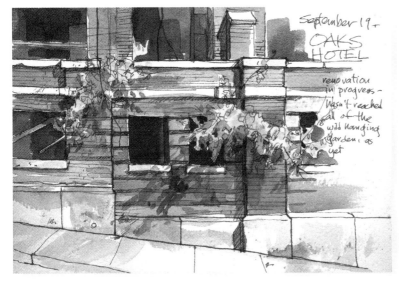

Hanging Garden Sketch

I did this small postcard-size sketch with a brown ink pen and quick watercolor washes.

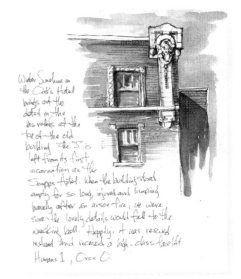

Detailed Restoration

I'm so glad the restoration company retained these beautiful details.

Exercise

Is there an old bridge that's going to be replaced? A wooded lot destined to become a high rise? A favorite greasy spoon or coffee shop that's undergoing restoration? Record the change—it's fascinating!

Time and Weather

We are often challenged by the fleeting moments and changing weather when working on the spot, even close to home. Learn to work fast if you need to, and get down as much as you can. Light changes quickly, but you can always exercise your color memory and dash in the colors you remember later.

Get to know your home territory in all seasons by exploring your own backyard. Jan Blencowe does just that on a regular basis and makes wonderful "field guide pages" to her own backyard, year round. You will forge connections with your home on a deeper, more intimate level than you ever imagined.

If you're working under harsh conditions, as Shari Blaukopf was in Quebec's wintry weather, do be sure to take care of yourself. You may choose to work from your car or a nearby window. Dress warmly if you're out in the cold weather. Layers are good, and fingerless gloves or mittens can help. Some artists even add a bit of alcohol to their paint water to keep it from freezing! Of course, you can always do the ink or pencil sketch on the spot and add color later if conditions are too harsh.

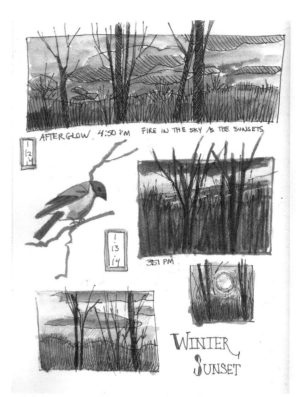

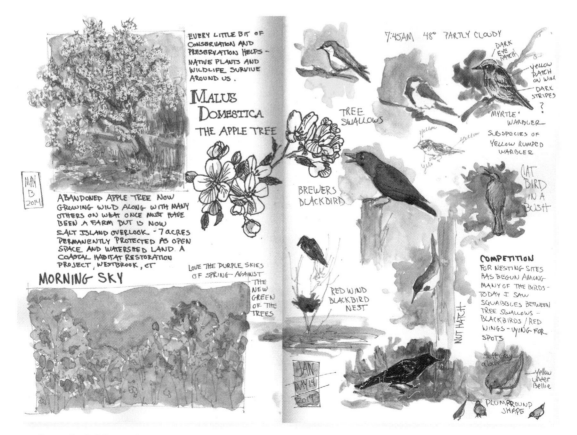

Backyard Field Guide

Here are two of Jan Blencowe's beautifully observed backyard nature sketches.

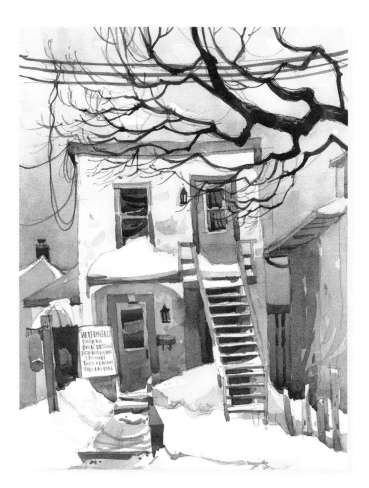

Winter Steps

Shari Blaukopf wrote, "The Chocolatier Marlain is one of my favorite Pointe Claire buildings to sketch in the winter. Since I paint in my car, parking spots are always important to me, and there is one directly facing this building. I love the welcoming entrance, the wonky staircase and the tree branches that frame the building, and they all look a little more charming in winter with a dusting of snow on them. In Montreal, it is almost impossible to sketch outside from November until April, so I have a great setup in my car. The water container is in the car's cup holder, my sketchbook is balanced on my steering wheel and my palette is on the passenger seat. And of course an occasional blast from the car heater is perfect for those washes that take too long to dry."

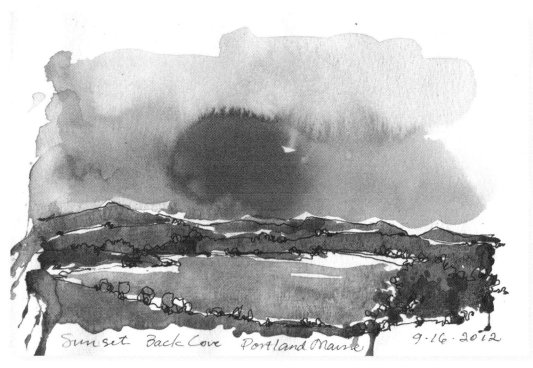

Working at Sunset

Jennifer Lawson worked fast to capture this sunset in Portland, Maine. A combination of ink and wet-in-wet watercolor washes successfully caught the ephemeral beauty.

Life in Your Sketches

Capturing a bit of life in your on-the-spot sketches can be a challenge—people and animals move!

You'll get plenty of practice working fast and capturing as much as you can in a short amount of time. A sketch needn't be a finished work you frame and hang on the wall.

Practice on the birds outside your window. A feeder or twelve will give you plenty of opportunity to observe bird life and, sometimes, the local mammals as well. Squirrels and woodchucks seem to enjoy the fallen seeds just as much.

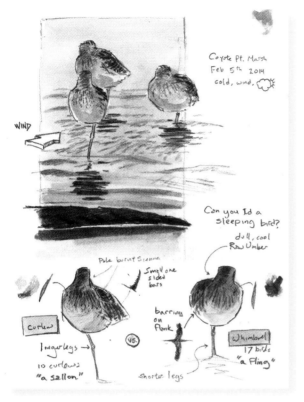

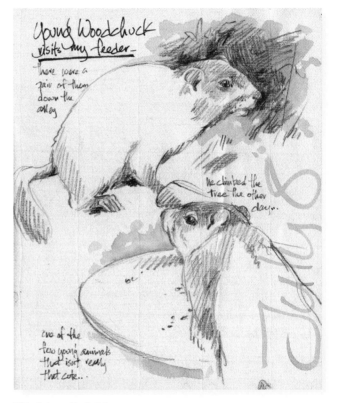

Draw the Shapes

John Muir Laws, author of *The Laws Guide to Drawing Birds*, suggests just drawing what you can see—if you can't see it, don't draw it. Get the overall shapes and don't worry unduly about detail.

Working Quickly

Working quickly in Prismacolor wax-based colored pencils, I only sketched what I could in a short amount of time. I went for the basic shape and then added details back into the overall form as the woodchuck continued to feed. Quick zigzag squiggles worked to suggest volume and shadow.

Exercise

Look around you, wherever you are—your kitchen, your studio, your backyard or garden. Then think about what truly says "home" to you. What speaks to your heart, right at this moment?

It might be your spouse, your child, your cat. It might be your bookcase or the rows of fresh vegetables in your garden. Perhaps it's your woodstove, fireplace or chiminea on a cold day. It might be your house itself! Whatever it is, sketch that and put your heart and soul into it.

Helen's dog Bula, who's as skinny as a comma...
Laura

Contained Energy

Laura Murphy Frankstone finds colored pencils to be excellent for capturing subjects that move quickly. Here, a friend's greyhounds lounge for a moment before bounding off. Look how Laura caught a sense of contained energy with those kinetic lines.

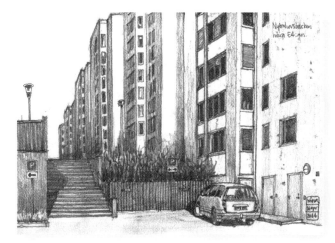

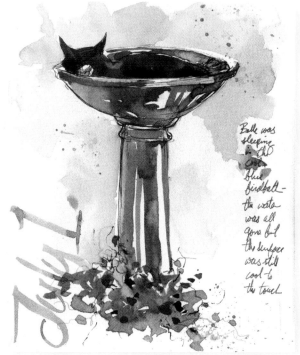

Tonal Values

Swedish artist Nina Johansson often sketches the neighborhood surrounding her urban apartment in graphite. The medium is particularly well suited to capturing subtleties of tonal value in a setting like this.

Simple Shapes

The gorgeous color and feeling of summery light made me grab my journal and my paints. My cat was sound asleep in the birdbath, so I captured her shape very simply and let the bright, strong color carry the image.

Interiors and Intimate Views

Sketching on the spot can mean working inside, too. Our homes are a haven, a place to rest, regroup and create. I've sketched the interior of mine dozens of times, small vignettes that really say "home" to me.

It isn't necessary to sketch an entire room or put in every detail. Focus on what catches your eye, like the way the light shines on a textured white wall, the shadows thrown by your favorite potted plant or the inviting shade of your screened porch.

In inclement weather—snow, heat, rain—continuing to work on the spot is not always easy. In addition, some of us are housebound, but that certainly doesn't mean we need to give up on the idea of working on the spot. This *is* our spot.

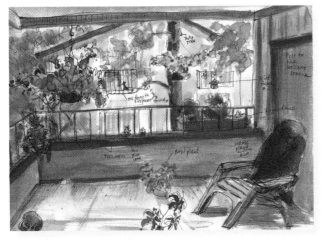

Inviting
Nina Khashchina utilizes toned paper, ink and a few touches of color to invite us into a corner of her home in Ireland.

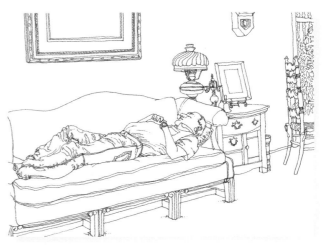

Draw Yourself
Put yourself in the picture if you want. After all, it's your home and your sketch! Warren Ludwig really looks comfortable on the couch.

Unlovely Bits

Not everything needs to be sunshine and roses, even close to home. Capture some of the darker, more serious elements as well for an honest, rounded impression. Let yourself feel what you're sketching, whatever that emotion may be. But remember, there is beauty and interest in decay. It's a kind of patina that the Japanese call wabi-sabi. It's a poignancy you don't want to miss.

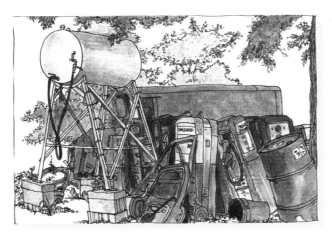

Complex Shapes
Warren used ink and watercolor to capture the complex shapes of gas pumps, tanks, car doors and more.

Foreboding Areas
Sweden's Nina Johansson caught the almost foreboding area under a Stockholm overpass, with concrete barriers and walls covered in dark graffiti. Ink and deep values speak of the mood she was after.

Capturing Changing Seasons

Sometimes it's good to look at our own backyards with fresh eyes. We realize the beauty of our surroundings and notice things we might have missed. A change of season can help with that, or an unfamiliar bird or animal. Here, gorgeous autumn colors caught my eye!

Materials
1" (2.5cm) flat brush, no. 8 round brush, assorted watercolor pigments, watercolor journal or sketchbook

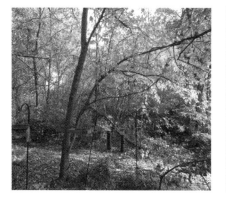

1 Capture the Image
I was intrigued by the glow among the trees (it was more pronounced in reality than it is in the photo).

2 Simplify and Wash
I applied wet-in-wet washes of Hansa Yellow Medium with a touch of Phthalo Blue for the color of the woods.

3 Lift and Scrape Color
While the background wash was still damp, I lifted the suggestion of light trunks with a brush dampened with clean water. Then I scraped some lines in with the edge of an expired credit card.

4 Add Tree Shapes
I applied a bit of Burnt Sienna spatter for lively interest. I wanted variety in the spatter drops, both in size and value, so they weren't too mechanical. As the background wash began to dry, I add the first tree trunks using a Burnt Sienna and Ultramarine Blue mixture.

5 Apply Final Touches
I added more tree trunks, shadows and a suggestion of leaves with more Burnt Sienna mixed with orange.

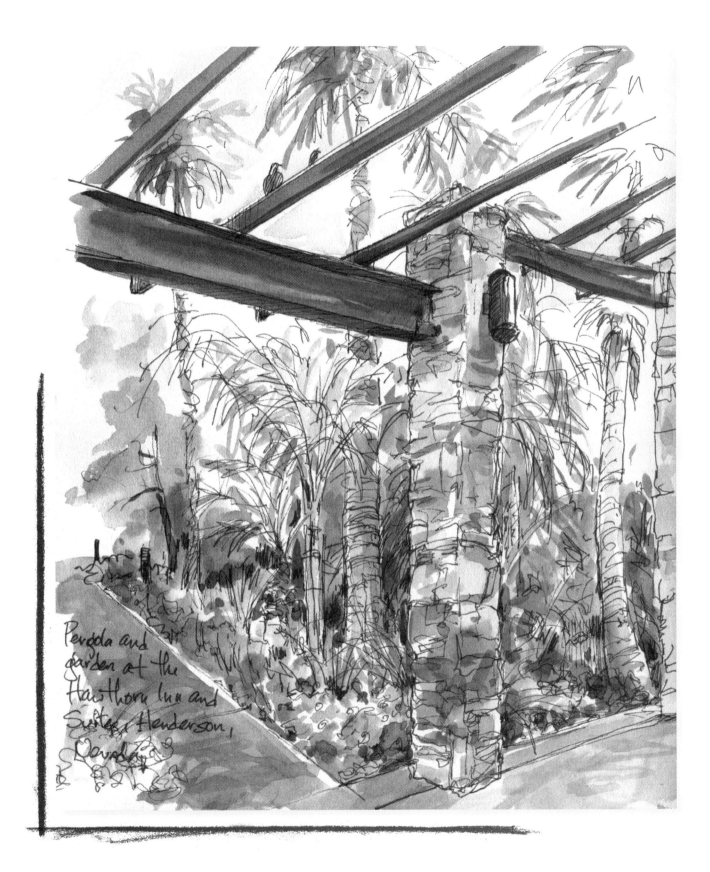

Pergola and
garden at the
Hawthorn Inn and
Suites Henderson,
Nevada

The Travel Bug

Whether for business or pleasure, travel can be broadening and a delightful way to learn, as well as to relax, recharge, regenerate and restore your delight in sketching. It can also be frustrating and exhausting. In this chapter we'll offer inspirations as well as tips to make it as satisfying as possible.

There are many challenges to making art on the go, but meeting them—or adapting without letting those challenges spoil your enjoyment—are part and parcel of the whole experience. "Be prepared" is still excellent advice, but you can pack too much in your desire to be ready for any contingency.

I recently gave myself a sore shoulder by taking too much stuff with me. My regular travel/sketching bag, which doubles as my purse, would have been plenty, but I burdened myself with my canvas tote with two more palettes, a spare journal and a ring-bound sketchbook I haven't touched in two years, plus a second water container and my camera! The fact that the place I ended up sketching was rather far from the Jeep meant I was lugging all this stuff much farther than I should have.

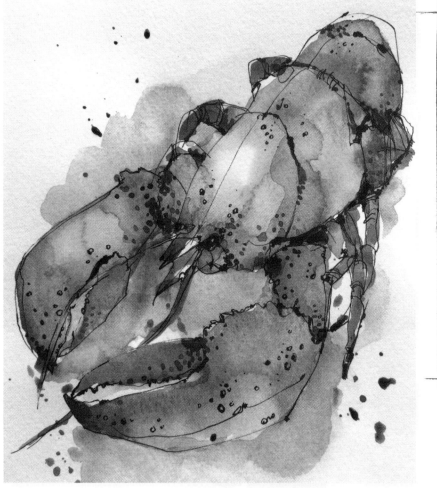

Exercise

Go back to the chapter on materials and supplies and look at what you *know* you'll need, what you *think* you might need and what you'd *like* to have with you just in case, then make a pile of each. If you're going to do most of the carrying yourself, weigh Pile 1. If that's not going to be a problem, add Pile 2, then weigh them together. If it's still not a big issue, toss in Pile 3.

Check out small rolling bags, like carry-on suitcases. Peripatetic artist Sandra Angelo claims that everything she owns is wheeled.

Fast, Loose and Colorful

Jennifer Lawson's quick, loose lobster sketch still looks delicious. The red color tells us it's ready to eat.

Keep It Simple

Granted, you may find yourself sorry you don't have X, Y or Z with you—I've done that more than once. But really, if I don't have six different pens, I simply decide that the two I have will do just fine. I may get a different effect than I'd originally planned (or hoped for), but sometimes that's truly a happy accident.

You can also adapt. Use one of the tools you have as a substitute, or in a different way. Consider tools that can do double duty. I always sharpen the ends of several of my wooden-handled watercolor brushes so I can dip them in paint to draw with or scrape through a wet watercolor wash for interesting linear effects. Also, cutting the end off a too-long brush helps it fit in your travel kit, which is handy, too, because it's difficult to find a large folding travel brush, and sometimes I want to be able to make a broad, wet wash.

Sharpened Tools

Consider sharpening the end of one of your brushes. It's like having two tools in one!

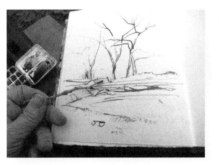

In a Pinch

Pick up a stick, dip it in your palette and draw with it.

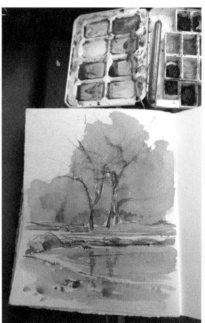

More Color Later

Add washes later if you want more color.

Scraping Tools

Cut up an expired credit card for a super-lightweight scraping or scoring tool. Make it an irregular shape so it's extra versatile. The planes and shapes you've trimmed the card to will allow you to scratch dark lines into a wet wash and scrape out lights of varied widths when the paint has begun to lose its shine.

If you're a watercolorist—or even if you just need to add a whisper of color to an ink or pencil sketch—that have-to-have, essential list generally amounts to a brush or two, your pigments/palette and a source of water. Many traveling artists choose to make do with folding or telescoping travel brushes,

a tiny travel palette and a source of water. You may prefer a waterbrush that combines a brush and water supply in one, but the largest brush is rather small and none hold much water, so you will need to work smaller than 5" × 7" (13cm × 18cm).

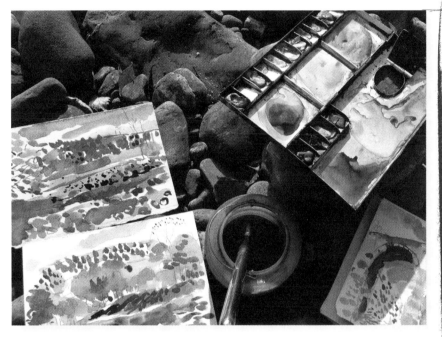

Simple Does It

British artist Sue Hodnett keeps it pretty simple. She gets delightful results with small watercolor blocks for sketches, a palette, water container and a folding travel brush.

Forget Me Not

Make yourself a note of what you truly needed the last time you were on the go but forgot to pack. Then keep the note with your gear! For some reason, with me, it's tissues. I use them to blot a spill, wipe a too-wet brush, make textures by wadding and touching a wet wash. How I consistently forget to pack them, I'll never know.

Once in a while I forget to refill my water container, too. My dear friend Vicky Williamson used to know to pack more and shared with me. Bless the woman! So, yes, it's a good idea to make yourself a checklist and look at it before you head out.

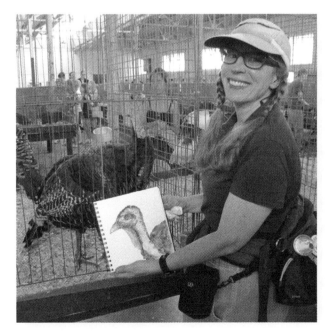

Tiny Kits

Roz Stendahl uses a tiny kit (like the ones on page 13) when sketching at the Minnesota State Fair. She works standing up, surrounded by hundreds of people, and manages just fine!

Finding a Subject

Find your subject by answering some of these questions: What catches your eye? What excites you? What's your focus? What's the story?

This is not usually a problem if we're regular on-the-spot sketchers. The real problem is likely to be that we feel overwhelmed with choices when traveling. There's so much, and it's all interesting and challenging!

Don't spend too long finding "the perfect subject." You may run out of time, particularly if you are traveling with others who prefer shopping, eating, cycling, fishing, climbing or museum-hopping. You don't have to draw the first thing you see, but do be aware that time may be short. Make the most of it.

You'll learn to focus quickly after a while on the road. You'll be able to zero-in on what captured your attention in the first place. If that's all you may have time for, start there! What moved you initially is likely to have the most impact and the best visual story to tell. Sketch that one lovely detail—a door or window, a fountain or an interesting form of ethnic or occupational dress. The possibilities are endless!

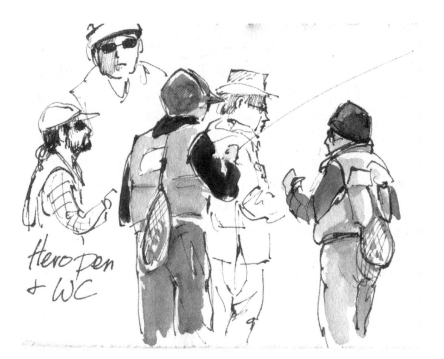

Fishermen

You can tell right away that the men in this quick sketch are trout fishermen. The vests and fishing nets tell the story at a glance.

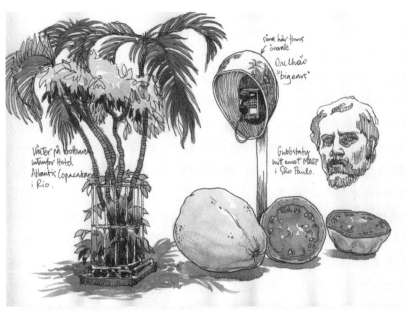

Add Detail

If you have time, add more detail and more background. Try to spread out from that one strong visual, but if all you get is that one detail, that's fine, too.

If you prefer, make a montage of all the details you observe. Nina Johansson did just that on this pleasing spread from a recent trip to Brazil.

Black and White

There's no need to add color. If you want to spend the available time capturing a more complex scene, as Don Low did in this burger joint in Singapore, feel free! Don often uses a bent-nib calligraphy pen for his on-the-spot sketches, then adds grayscale volume as he did here.

Take a Moment

I'd passed this little burger place a dozen times over the years and had never taken the time to stop and sketch it. Last time we were in California, I knew I'd better get at it! From my vantage point across the parking lot, I did a quick sketch in ink, then splashed in watercolor. (The car had moved by the time I got to that stage, so I just suggested it.)

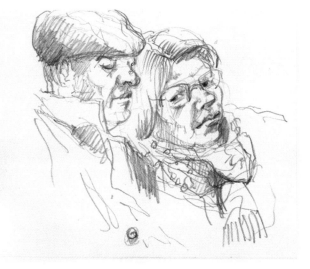

Add Detail

Nik Ira captures life with a capital L with a soft graphite pencil on toned paper. You can feel the relationship between these two people as if you knew them personally.

On the Go (Fast Sketching)

Often when we travel, we're struck by something we see on the way from here to there. Be ready to work fast! Get down the basic forms or actions; you can add to it later from memory, from a photo or from inspiration.

Keep your basic tools handy so you don't have to fumble for your supplies. I usually have a favorite pen, pencil or colored pencil where I can get at it fast.

Sometimes it's good if we don't have time to sit and finish a sketch on the spot. It allows us to add the colors that capture the mood later, rather than being trapped into trying to match the complex mosaic of local color.

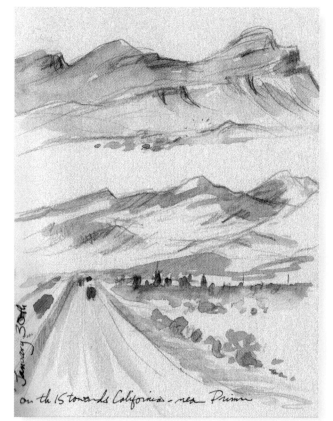

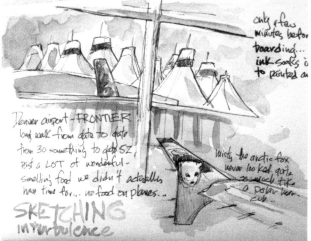

Tarmac-Eye View

If you're sitting on the tarmac, of course, you can sketch what's out the window: The distant landscape, palm trees, other planes waiting to take on passengers and the rest of the terminal building.

Car's-Eye View

Sketching from a car window often calls for working fast as the landscape flies past you. Don't try for detail. Again, just draw the basic shapes and energy as you ride by.

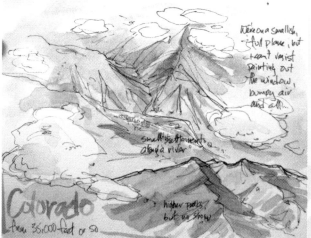

Bird's-Eye View

I've sketched some stunning old volcano craters, shorelines, canyons and mountains while looking down from plane windows.

Be Prepared

Often, we may find ourselves in an environment very different from the one we're used to. Do a little pretrip research on what challenges you may face, physically, and what materials will work best.

Will it be scorching hot, making your paint dry almost before touching the paper? Will it rain all the time? Will your fingers freeze along with your paint water? Will there be places to sit, or a good source of water? Find out.

Sketching With a Stool

Take a folding stool if you might need one. Warren Ludwig's, shown here, is quite simple. You may want one with a pocket on the arm, or beneath the seat, to hold some of your gear. Some even have a strap so you can carry them over your shoulder.

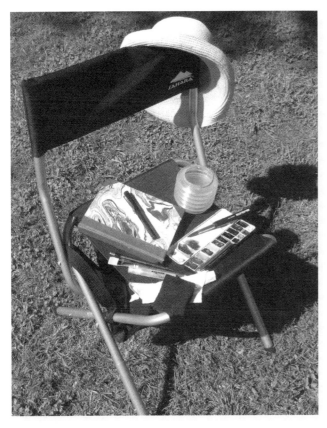

Storage Areas

Vicky Williamson's chair also has handy storage underneath to carry her tools.

Comfort Drawing

Being more comfortable allowed Warren to complete this beautiful, complex Rialto Beach sketch.

Of course, many artists opt to work without seating of any sort. It's not a necessity, and you can almost always find somewhere to settle down—under a tree, in a café, on a stone wall or boulder. Plus, if you're on the ground, all your materials are handy without having to bend over!

Laura Murphy Frankstone travels in a wide variety of environments, from sunny Italy to the frozen tundra. She researches ahead of time, not only for what media may work best under specific conditions, but even which colors may be most needed in her palette. Cool blues and grays (plus brilliant color for some of the volcanoes she's visited) work in colder climates, while rich greens are needed for the Pacific Northwest. She might even switch to toned paper if it captures the overall mood, as in the sketch on the right.

Colored Paper

Laura Murphy Frankstone used pencils and colored pencils on gray paper for this sketch.

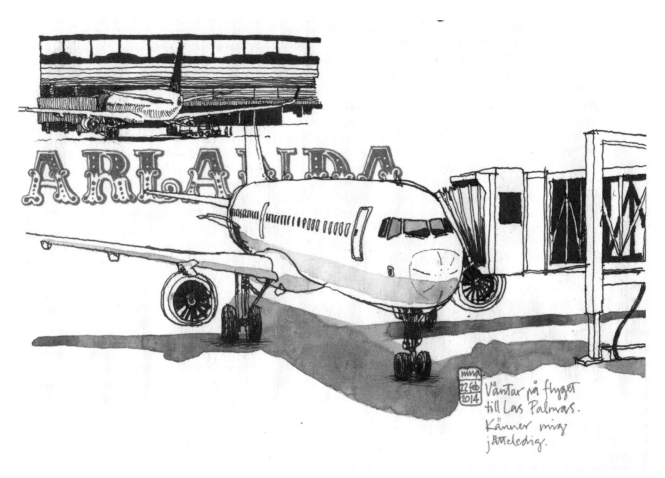

Window Seat

Ask for a window seat. You can get some terrific sketches while you wait to be cleared for takeoff, as Nina Johansson did here.

Airport Sketching

It's fun to sketch your conveyance, as well! Since you don't have a TARDIS, why not sketch your car, bus, train, airplane or ferry? Or the airport itself?

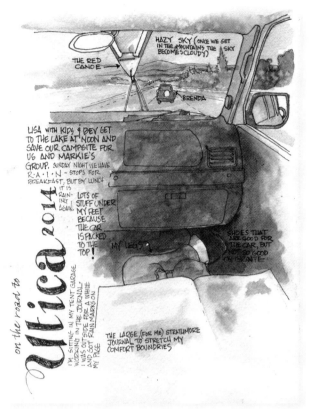

Passenger's Seat

Journal keeper Gay Kraeger often works in her car—from the passenger's seat, of course!

Boat Seat

A relaxed Alissa Duke sketched her own knees and sketchbook as she took the ferry to Manly, in Australia.

Weather

Being prepared for the weather can be the difference between a pleasurable and productive experience versus a pretty miserable one. A lack of preparedness can even be dangerous in some circumstances.

Extreme heat not only makes painting difficult as your paint dries right on your palette, but it can cause dehydration and heat exhaustion, or worse. A sudden drop in temperature or even a thunderstorm can suck the heat right out of your body. So, pack accordingly.

We may be surprised if the weather changes rapidly, but being ready for most foreseeable contingencies is generally a good idea. Check the weather report before setting forth. Make sure you have plenty of water to drink as well as to paint with. Fingerless gloves or mittens may let you sketch a bit longer when it's cold out. Plan on taking layers so you can add or subtract a jacket or sweater (or more) as the temperature fluctuates.

Brewing Storms
On this day, we got caught in a storm and were soaked on the way back to the truck, but our sketches stayed dry!

On Your Toes

Be prepared to move quickly if you need to. Rain may come up suddenly and drench you and your hard work. Sometimes, if the weather report is threatening, I choose to work smaller. Not only is it faster, but you can actually shield your work with your body if it's small enough!

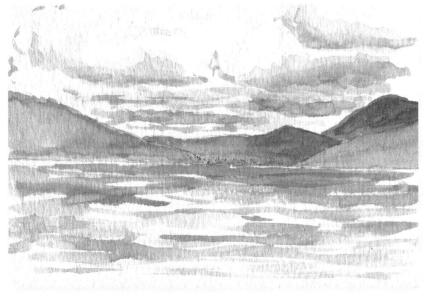

Be Prepared
This little painting is about the same size as a snapshot. My husband and gear-carrier, Joseph, prefers to work this size, for convenience and portability. He usually has his kit in the pocket of his cargo pants, at the ready at all times.

Brave the Elements

Expeditionary Art owner Maria Coryell-Martin has worked on the spot under some incredibly harsh conditions. Snow and ice don't appear to daunt her in the least; she's prepared and dresses accordingly. Take a peek at this demonstration done on the spot in Niaqornat, Greenland, "the village at the end of the world."

Materials
assorted watercolor pigments, graphite pencil, watercolor journal or sketchbook

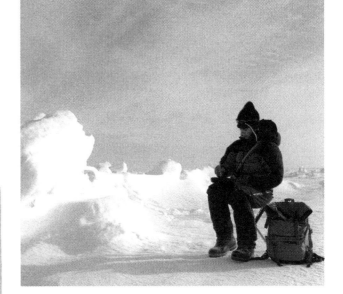

Winter Wonderland
Here, Maria has the best seat in the house for her winter landscape.

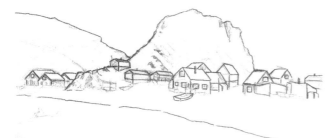

1 Capture the Image
A quick pencil sketch orients the village and mountains on Maria's page and lets her settle on her composition.

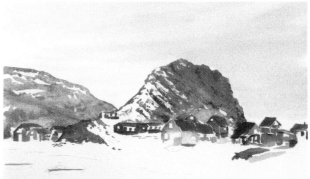

2 Place the Color
She planned the color and placement, then applied the initial washes.

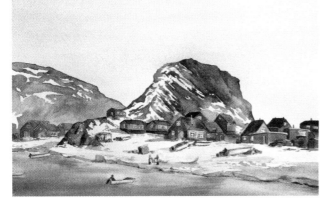

3 Apply Final Touches
She developed the painting and added details.

Use materials that will cooperate in the weather you'll be dealing with as well. If it's very cold, you may have to keep your pens or waterbrushes inside your clothes until they're ready to be used, or stick with a graphite pencil. (I recently had to hold my frozen pen in my hand until it thawed enough to use!)

Colored pencils may work better for you than watercolors, in some instances (though some artists add a bit of alcohol to their paint water in bitter weather to keep it from freezing). Be aware that watercolor crayons or wax pastels may melt or crack and dry if it's too hot, so don't leave them in a car in the summer. Even regular colored pencils can dry out and crack in harsh weather.

A broad-brimmed hat may help shade you and your paper if you're painting in the sun, where your paint tends to dry quickly. Also, polarized sunglasses help keep you from going snowblind with white paper in the sun, too. They may affect your color sense but not nearly as much as the glare off of your paper.

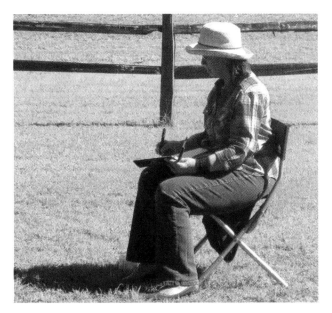

Shade Casting

In the strong sunlight, Vicky Williamson wisely opts for a hat to shade both herself and her paper. Notice how she's also positioned herself with her back to the sun to cast additional shade on her work surface.

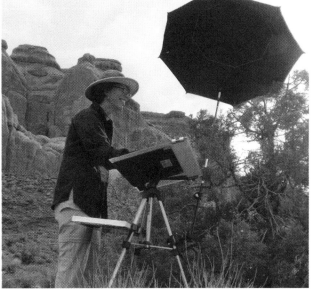

Sun Protection

Abroad in the American Southwest, Canadian artist Shari Blaukopf packed an artist's umbrella for sun protection.

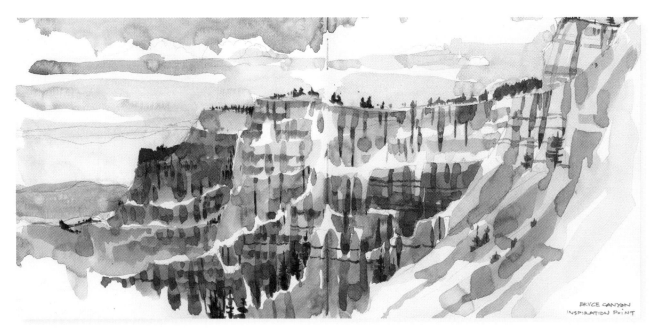

Shade Payoff

The shade paid off, allowing Shari to judge both color and value in this gorgeous watercolor.

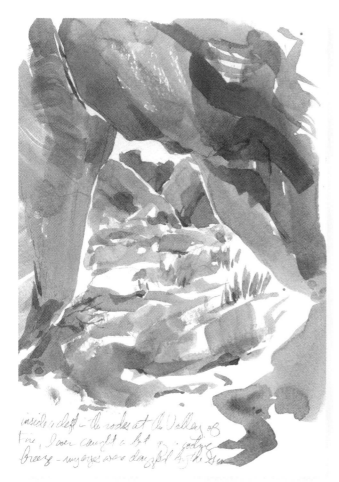

*inside a cleft - the rocks at the Valley of
Fire, I never caught a bit of judge
breeze - my eyes were dazzled by the sun*

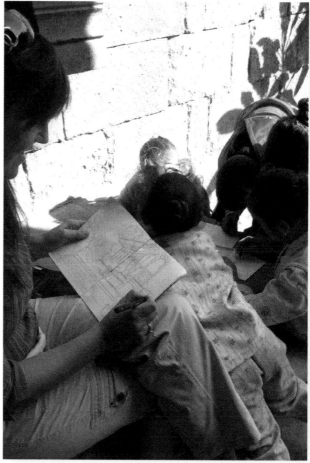

Under a Rock

For this sketch, I crawled into a hole in the rocks (watching for snakes, scorpions and other desert beasties, of course!) and sketched from there since it was the only shade around. I used a combination of Burnt Sienna, Quinacridone Burnt Scarlet and Ultramarine Blue. I left a lot of white paper to suggest the searing hot desert sunlight.

Sketching With an Audience

Botanical artist, Shevaun Doherty often attracts an audience of adults and kids as she sketches. Here, the children have settled in to join her in drawing.

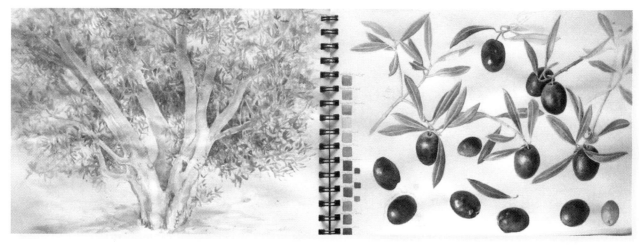

Close-Ups

Shevaun Doherty often paints close-ups of what she's drawing. These gorgeous, ripe olives seem to pop off the page!

Options

You can find room to work almost anywhere: a broad windowsill in your hotel room, an airplane tray table, your car's glove box (this works in my Jeep, anyway!) or a crowded café. You can even work standing up, balancing your pencil, journal and paints, if you keep it simple and lightweight. The thing is to *do* it!

Window Protection

I sometimes paint from inside my car or out the hotel window if the weather's not cooperative. Most hotels and motels have wide windowsills or heating/AC units that can act as your taboret. The view can be spectacular or mundane, but it's still a great record of your travels.

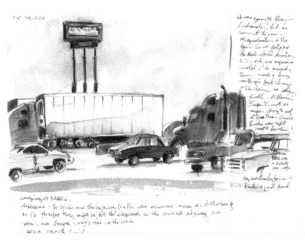

Motel Views

We were forced to stop at a motel by a truck stop due to a downpour. Although the view wasn't that stunning, and my colored pencil turned out to be water-soluble, I really like this sketch. It reminds me of exactly how wet it was.

Bug Out

If insects are a problem, wear long pants and long sleeves or pack repellent. Slapping mosquitoes or black flies while sketching is neither nor productive. Ask the locals how they deal with black flies, ticks or other local irritants.

While sketching in the desert, my husband warned me: "If it doesn't bite, it stings, and if it doesn't do either of those things, it has stickers or thorns." I managed to avoid almost all of those dangers, but I'll admit it was mostly by sketching through the windows of the rental car and hotel room (as shown on the left).

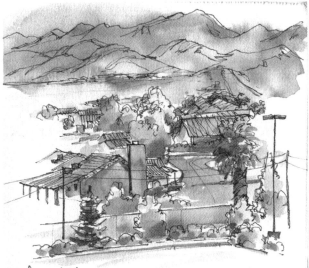

Nevada Mountain Sketching

When traveling, I always try to capture the feel of a place. This trip, we got up and out early so we could sketch the desert before it got too hot.

Materials
1" (2.5cm) flat brush, no. 8 round brush, assorted watercolor pigments, graphite pencil, sketchbook with cold-pressed watercolor paper

1 Capture the Image
A couple of quick thumbnail sketches in pencil helped me to plan shapes and composition. Taking time for these is not really necessary, but it can be good practice if you need to focus.

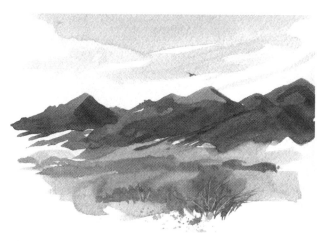

2 Create a Quick Study
The light was changing rapidly and I wasn't sure how long we'd have, so I made large washes that wouldn't dry up too quickly. I used very fast strokes, letting the colors blend wet-in-wet.

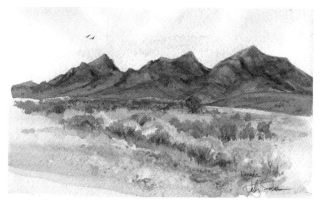

3 Create the Final Painting
I had learned a lot with my quick sketch, so I did a second painting of the same scene using the same colors but with more detail.

I took my time on this one, painting the sky wet-in-wet, allowing it to dry, then adding the mountains and the desert foreground. A bit of clear water spatter was added to the textures of rock and sand, closer to the viewer.

Waterfall

Go with your medium's strengths, particularly when time is short or weather is threatening. On a recent fishing trip, rain had been falling off and on all day, with more to come. So I dispensed with a great deal of preliminary planning or even elaborate pencil guidelines. I used a simple line to show where the edge of the dam was, and that was enough; I jumped right in with paint.

Materials

no. 12 round brush with a sharp end, assorted watercolor pigments, cold-pressed watercolor paper, graphite pencil

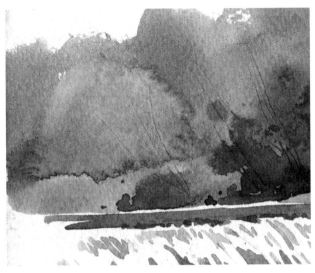

1 Apply Washes and Initial Texture
I used the slightly rough texture of the paper to suggest foliage at the tops of the distant trees, painting them with a quick drybrush effect. Then, I dropped wetter, lighter-colored paint into the green trees in the background, which made a lacy foliage-like effect as it pushed the dryer pigment back.

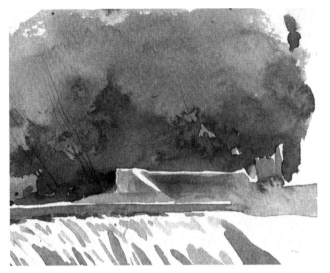

2 Incorporate Light
I painted around the light-struck edge of the concrete barrier rather than taking time to mask it out, and dropped in a bit of light green in the lower right while it was still wet, both to suggest weeds and to integrate the form.

3 Apply Final Touches
Develop the moving water on the dam and add final details as desired.

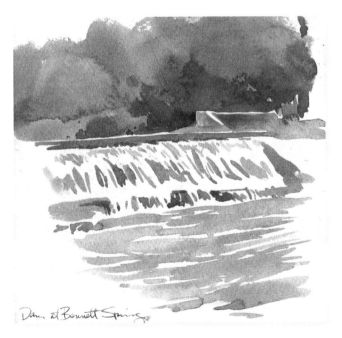

Dam at Bennett Springs

Before her artist-in-residence trip to Alaska, Nina Khashchina did a great deal of research on what she might need to take and how likely it would be to stand up to extremely wet conditions as well as to rapid change.

Here's her quick rundown: "Before going to Alaska I did a bit of research on what paper would withstand water/rain and found this 'rite in the rain' company that creates paper which is weather resistant. This is what I used while drawing in the rain—in serious rain and while in a kayak. I dropped my pad in the ocean, I splashed it in the tide, it was all over the place and it worked."

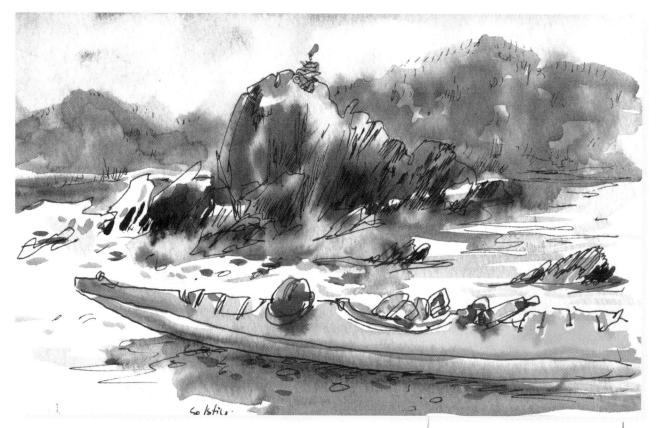

Bolder Lines

Nina said, "For my Alaska trip, where I drew while ocean kayaking and in the rain, I tried all kinds of pencils: a regular no. 2, a couple of softer pencils, watercolor and colored pencil. The best one for me was Stabilo All Aquarellable pencil 8008. I found that, if you have water, it draws bolder and more liquid lines, almost like paint. I used my fingers and anything that was lying around to try different marks with this graphite. However, if the paper is dry, I prefer Prismacolor pencils."

Rite in the Rain

If you're looking for water-resistant paper like the kind that Nina Khashchina used on her Alaskan trip, visit this website: riteintherain.com.

Interpretations

It's fascinating to see how different artists handle similar subjects on their travels. Take a look at these five interpretations of the ocean. They're great reminders that there is no one right way. Let your travels speak to you!

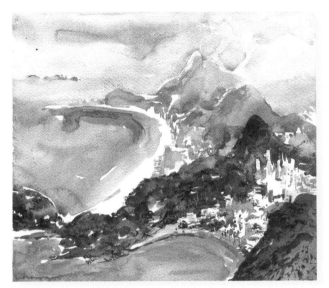

No Underdrawing

Marc Taro Holmes simplified this sweeping landscape and used wet washes with no previous underdrawing.

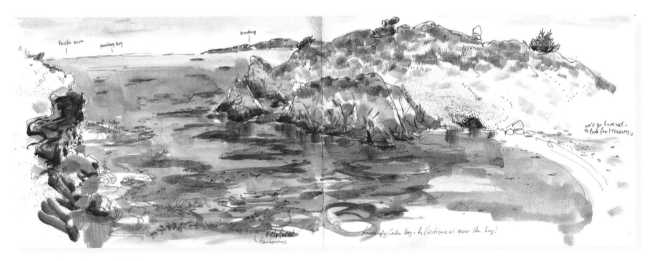

Loose Sketch and Notes

Nina Khashchina used a pen and black ink to loosely sketch the forms before her, making written notes along the way. Then she added quick washes of color.

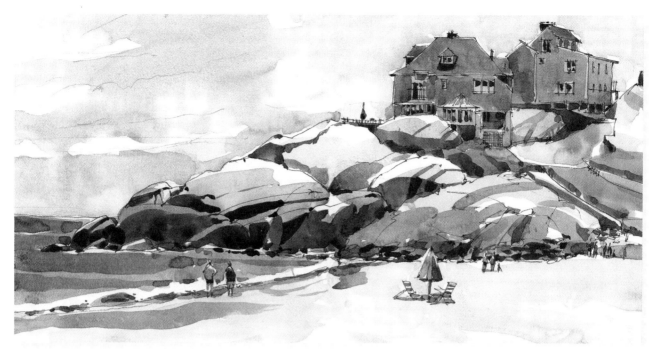

Sense of Scale

Canadian watercolorist Shari Blaukopf concentrated on the shape of the shoreline rocks and the buildings, using an ink pen with a fine nib and the fresh washes she's known for. The people on the beach give us a sense of scale. Try introducing people in your sketches to make the scene feel more human.

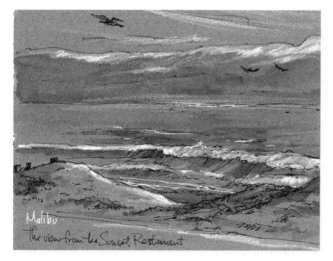

Shape and Action

I did this ink, watercolor and colored pencil sketch while sitting in a restaurant in Malibu, California, with my husband as a fog bank crouched at the horizon. I paid special attention to the shape of the sand hills as well as to the action of the waves. My supplies were simple and lightweight and didn't get in the way of our meal.

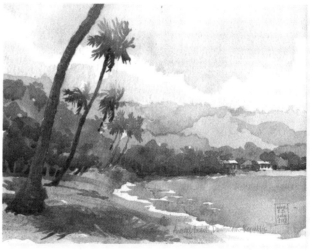

Fresh, Clean and Simple

Painting in the Dominican Republic, Swedish artist Nina Johansson kept her colors fresh and her washes clean and simple.

How Will You Travel?

How will you reach your destination? By car, plane, bike or on foot? Jennifer Lawson took an extreme sketching adventure recently. She walked 500 miles in 32 days on Spain's El Camino, with art supplies in her pack.

When I asked her how she dealt with sketching on the trail and when she had time, this was her delightful response: "I mostly sketched once we arrived at our destination, which was usually mid-afternoon, so it offered me time to enjoy, explore and sketch. Once in a while I sketched in the morning before we left or out on the road, but that was usually too complicated, and time was an issue."

On a trip like that, where you must carry everything, including your art supplies, you really have to plan ahead carefully.

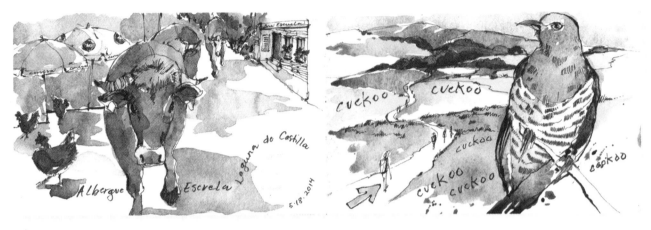

Hiking Journey
From villages to mountains to wildlife, Jennifer Lawson found plenty to draw on her long hike.

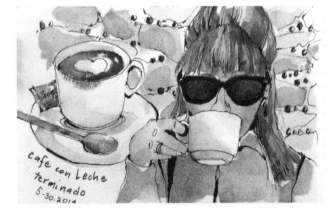

Research
Research your route if you're going to undertake a journey like this. Be aware of what your options are. As this sketch shows, there were lovely opportunities for food, wine and drawing at stops along the way.

New Twist
Kolby Kirk hiked 1,700 miles on the Pacific Crest Trail, from Campo, California, to Etna Summit, California, carrying everything he needed. Kolby devised this clever palette by cutting off a section of watercolor pencils, then shaving them back to expose the lead.

Camping

How you like to travel is up to you. You may prefer roughing it: Camping in a tent and sleeping on the ground while cooking over an open fire. You may have a small studio setup in your RV (or, as I do, tucked into the console of my Jeep). You may feel most comfortable in a bed and breakfast, a motel, a small cabin or an elegant old (or new!) hotel. I've explored most of these over the years, and they all offer different travel and sketching experiences.

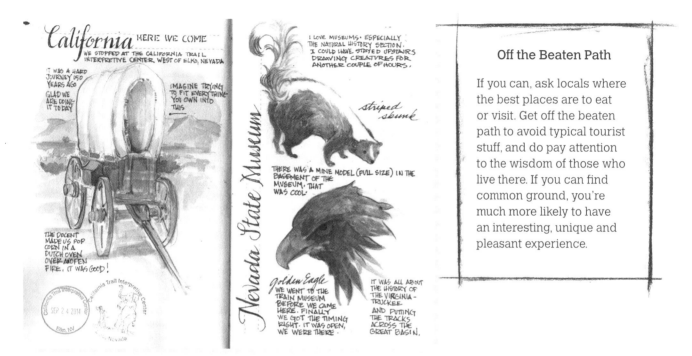

Off the Beaten Path

If you can, ask locals where the best places are to eat or visit. Get off the beaten path to avoid typical tourist stuff, and do pay attention to the wisdom of those who live there. If you can find common ground, you're much more likely to have an interesting, unique and pleasant experience.

Old-School Camping

Journal keeper Gay Kraeger couldn't resist sketching this covered wagon and speculating on carrying all kinds of gear in it.

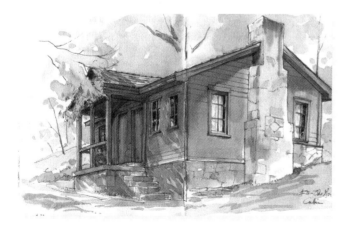

Accommodations

Sketch your accommodations! They'll stick with you longer and make a wonderful memento. We've stayed at Bennett Springs many times, always in one of the three old Civilian Conservation Corps cabins built in the 1930s. I love all of them, and have sketched all three over the years. This one is known as The Governor's Cabin, because every Missouri governor has stayed in it since it was built.

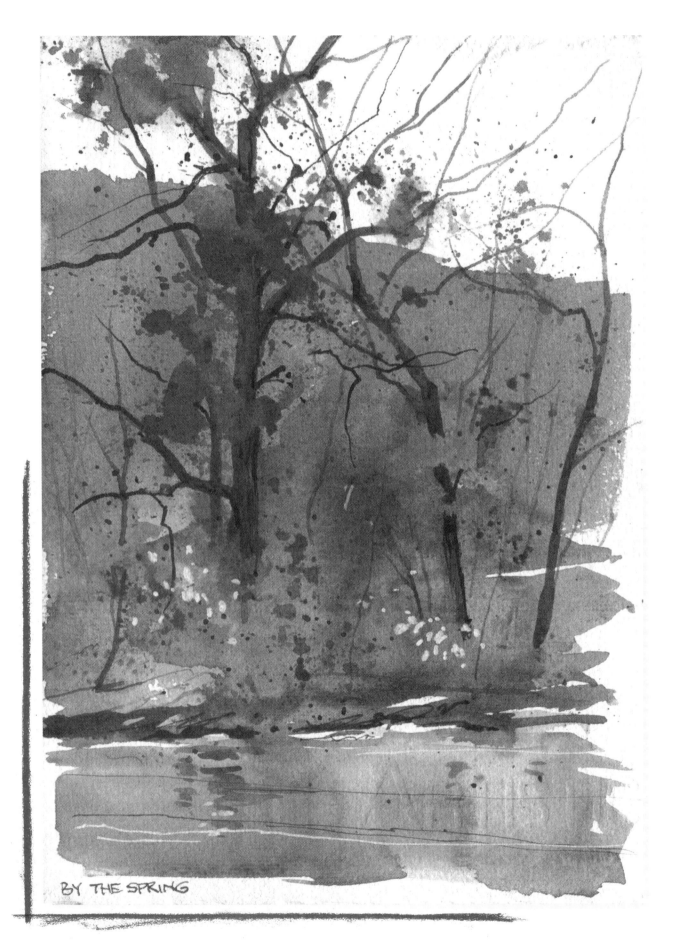

BY THE SPRING

Nature Sketching

When I was a little girl, I used to read my grandmother's natural history books from the late 19th and early 20th centuries. I could imagine no better life than being outside—drawing, writing about the natural world and learning about my place in it. I spent a good portion of my admittedly charmed life doing just that, and I haven't regretted a single moment. I'm never bored, and each observation seems to supply me with a new handful of great questions to explore.

One of the most fascinating ways to learn about your corner of the world, or anywhere you may travel, is to sketch it. Not just the grand vista, but the things that live and grow there, getting nose-to-nose with nature. (Well, maybe not with a poisonous snake, but you get the idea!)

The shells you find on the beach, the fossils in the rocks, wildflowers at your feet, even the vestiges of prehistoric human occupation can all teach us so much. Not the least of which is to appreciate where we fit into the equation ourselves. I find that what we draw we begin to understand, then to appreciate and then, naturally, to want to protect. It becomes part of our tribe.

Ask yourself: What birds do you see, who visits your feeders and what food do they seem to prefer? Then look for ways to capture what you see quickly. I love something that John Muir Laws stresses in his book on drawing birds: *Just draw what you see. If you can't see it, don't draw it.* Somehow that removes a lot of stress, doesn't it?

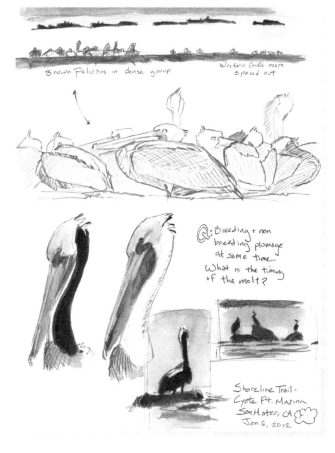

Helpful Tools

John Muir Laws often uses a telescope to get close to his subjects, but he may only draw the part he can see clearly.

Multiple Observations

This page shows a variety of observations: Pelicans in the distance, up close and in various positions. Notice how John asked questions right on the page so he could later research further. Likewise, he wrote down the locale and the date. That kind of information is invaluable in nature study.

the Big Picture

Landscapes are so much more than just scenery. They can include whole biosystems: the plants, animals and other creatures that live there. They are nature, writ large. They show their bones and their history.

Don't forget the geology of your chosen area: What formed the landscape you see? An inland sea once covered the land of my home state. When the sea receded, it left behind limestone bluffs and a myriad of fossils.

Still later in prehistory—a mere 10,000+ years ago—my home state was partly covered by a glacier, creating loess bluffs. These bluffs changed the course of rivers, leaving behind a scattering of pinkish granite rocks and boulders, known as glacial erratics, that began their journey hundreds of miles to the north, pushed along by that wall of ice. Today we see these travelers, large and small, in fields, yards and gardens.

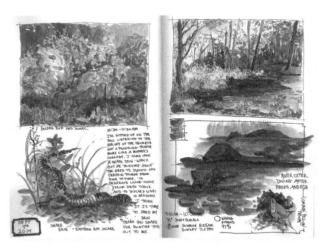

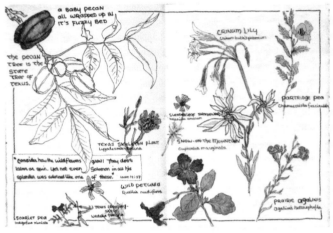

Habitats

Jan Blencowe caught river otters at play and managed to capture several sketches of these beautiful animals. Notice she also included a habitat sketch and made notes of her observations.

Flora

Vicky Williamson just moved to a log cabin in a new state and is getting to see and draw the flora and fauna she hadn't seen before.

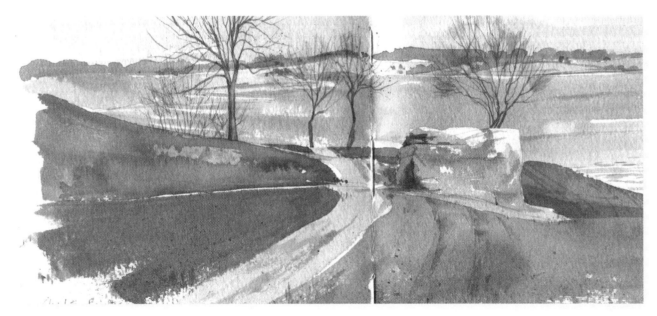

Glaciers

One of the largest glacial boulders in my area is near what is now Smithville Lake. The boulder was, no doubt, a landmark for indigenous people for hundreds of years. I have one of its siblings in the little rock garden at my shed.

What makes your area unique and what formed it? That's a question I often ask when I travel, as well. Where you live, there may be mountains rucked up by settling plates deep inside the earth, ancient eroded cliffs of sandstone, level plains and so many more hidden tidbits!

Ask yourself questions: How did this land get this way, and why is it so different from home? What grows here, and why? Few realize that specific types of soils affect plant growth in many different ways, as does the amount of rainfall.

Mountains

Australian artist Liz Steel captured the rough slumped earth of the famous Mount St. Helen's face after the volcanic eruption in 1980. Working quickly in ink and watercolor, she clearly captured the details of the collapsed cone.

Prep for Mountain Sketching

Liz keeps it fairly simple when she works on the spot, finding a place to sit wherever she is. As mentioned earlier, her research and trip planning prepares her for virtually anything!

One year, I did a landscape in Maine and a landscape in Nevada, and the two couldn't have been more different. Both were beautiful and challenging, but not even distant cousins.

Different areas may require adjusting your working methods as well as the colors you choose. Your materials will respond to the change in humidity and temperature. Be prepared, and you'll still be happy with your results.

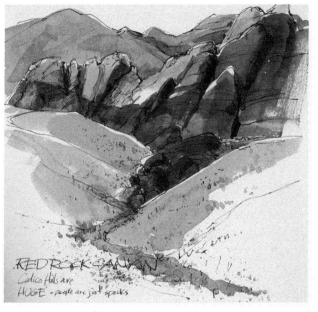

Red Rock Canyon

Sitting on the side of a hill in Nevada's Red Rock Canyon, I did the initial drawing with ink as a guideline. This let me slap in the watercolor washes quickly before they dried up.

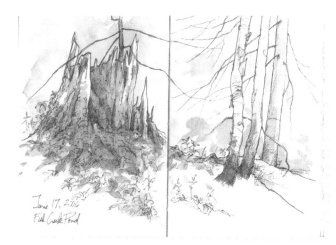

Woods

These woods upper New York state were incredibly lush. I wandered off into the forest away from the camp and sketched to my heart's content. I'd been feeling rather overwhelmed, and journaling in the woods was just what I needed. All that silent green!

Elements of Landscape

Of course, as I often say, it's all just shapes. Don't let anything intimidate you. You're sketching to learn, to experience, to relax, to celebrate and to immerse yourself in the now—don't make it a chore. Don't say or think that you can't because it's too hard. It's not. However you express yourself, it's fine.

Work fast and capture the basic shapes, or take your time and work slowly and meditatively—whatever approach works for you at the time. Ask yourself questions, if that helps you to see more clearly. For instance, how wide does that road look in the distance in comparison to the foreground? How does that tree limb join the main trunk and how big does it appear in relation? What kind of texture does that boulder have?

Trust your eyes and your perceptions! Draw what you see, not what you think you know. Draw what you're feeling, too. If a different color scheme expresses your mood better than the colors you see, use them. Sometimes I like to add color to my sketches later, rather than trying to match the colors I see before me. It's freeing.

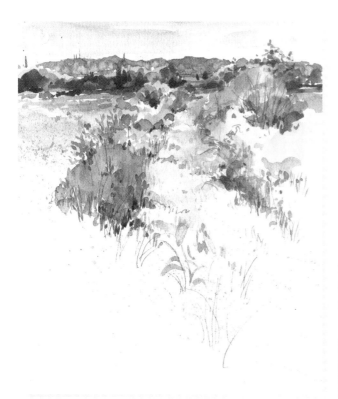

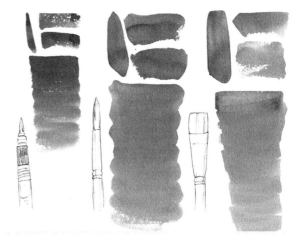

Brushes and Brushstrokes

From left to right: Large waterbrush, no. 8 round brush and a ½" (1.25cm) flat brush.

More Details

Here, I went for more detail by using only a single, large waterbrush and a small dip pen loaded with watercolor for the more linear areas. (The biggest normal waterbrush is about the size of an average no. 6 round watercolor brush.)

Paper Size

When you're painting a landscape, the size of the paper you're working on may dictate your tools or materials. I was working relatively small on the sketch of Cooley Lake here, and used a number of small strokes with my waterbrush. Other times, you may need a brush that holds a lot more water and pigment than a waterbrush can.

Dry Atmospheres

Painting in California's dry atmosphere was a lot different from working in the super-humid Midwest. I found myself frustrated by how quickly washes dried. There was no shade to be found, and the angle of the sun made it difficult to use my body to cut the glare. This resulted in me having to use a number of fast painting tricks.

Materials
1" (2.5cm) flat brush, bristle brush, assorted watercolor pigments, cold-pressed watercolor paper

1 Apply Washes
I made a huge wash of Raw Sienna and Quinacridone Gold and laid it on with my biggest brush, working as fast as I could. A second, darker wash made by adding more Ultramarine and Burnt Sienna pushed the far hill back into shadow. I splashed in some dark green while that was still wet to suggest more brush on the hillside.

2 Create Trunks and Branches
I used a rough bristle brush to lay in the bushes quickly. While they were still damp, I scraped trunks and branches into the dark green wash. I used my favorite Phthalo Blue and Burnt Sienna for rich dark greens.

3 Add Texture
Spatter and more scratching in the shadow areas give the illusion of texture on the steep hillside.

4 Add Final Details
Apply any additional touches and let the painting dry.

Relationship With a Place

If you're fortunate enough to have a longtime relationship with a place, as I have with Cooley Lake, record the changes with your sketches. It's fascinating to see how a biosystem evolves over time.

Cooley was once a bend in the nearby Missouri River. The riverbed moved, as they do from time to time (especially in flood), and now it's a shallow lake. In times of drought, it's Cooley Mud Flats, but after some good rains it has enough water to attract a wide variety of waterfowl again.

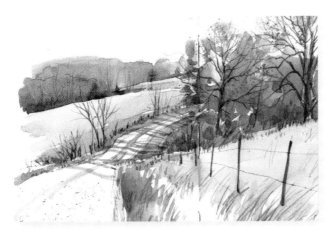

Suggested Distance

I sat in my Jeep to sketch this familiar country road in my journal. You can see the road and the receding line of fence posts worked together to suggest distance. I also kept the background forest much simpler than the things closer to the eye.

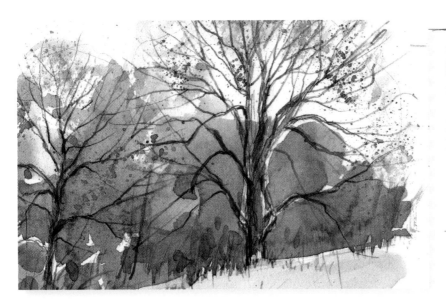

Atmospheric Effects

Use aerial perspective in your landscape sketches. Things in the distance often appear smaller, lighter and higher in the picture plane. They may be cooler or bluer, as well.

Spatter Leaves

I paid attention to the shape and diminishing size of the limbs on these bare oak trees, then used a bit of spatter in a warm color to suggest the new budding leaves.

Demonstration

Park and Sketch

There's a dam-like service road that separates two arms of the lake with a perfect place to park and sketch. I have no idea how many sketches I've done just from this spot.

Materials

no. 10 round brush with a sharpened end, assorted watercolor pigments, hot-pressed watercolor paper

1 Apply Wash and Marks
Small brush marks, linear marks and spatter work suggest the weedy summer foreground.

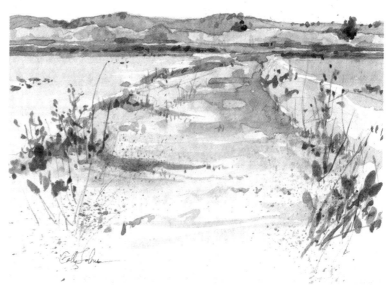

2 Color Middle Ground
The middle ground is fairly simple, with quick washes and glazes. No need to overwork to get the point across.

3 Create Soft Forms
Here I used simple pencil guidelines that would show under the loose watercolor washes. Some washes, like the warm colors, I painted wet-in-wet so they'd spread into dryer washes to create soft tree-like forms. Others I painted wet-on-dry for more defined strokes to suggest the darker trees on the far hill.

4 Add Final Details
This was painted on the spot, en plein air and relatively quickly. It's not necessary to try to reproduce every detail because the eye fills them in.

Painting Expressive Water

There are as many ways to sketch water as there are bodies of water. Think of oceans, streams, still lakes, waterfalls, floods, even a rain-wet street. Just map the shapes, perhaps doing a small, fast thumbnail or an under-sketch guideline in pencil, and then jump right in! (Figuratively, of course.)

A quick sketch before you start may help to clarify what you're seeing in your mind or simply slow things down and set the mood. Take a deep breath and give yourself time to really see what you're looking at. Pay attention to the shapes of streams and rivers, as well as to the negative shapes that surround them like banks and curves. Accurate observation helps these waterways to look natural, and perspective comes into play once again.

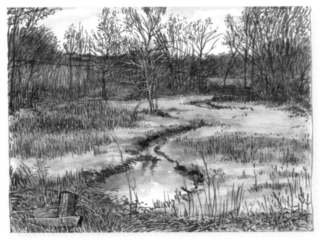

Shape of Water

Warren Ludwig has carefully observed the shape of the small body of water in this marsh.

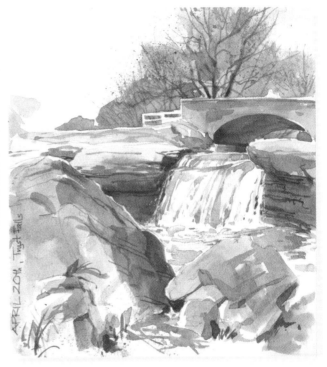

Moving Water

Painting a waterfall, or any other moving water, isn't that difficult. Just pay attention to repeated shapes, look for where the turbulence occurs and see if you can tell why. Leave white paper for sparkle, and vary the color to keep it lively. The medium you choose also affects how you depict moving water. An ink sketch will use a different approach, as would an opaque medium like gouache or acrylic.

You can scrape out light sparkles with a sharp blade once the watercolor wash is dry. Notice the broken white lines on either side of the falls. I keep a tiny Swiss Army knife in my kit that works perfectly for this.

Moving Water

Moving water doesn't generally have reflections, but do try to determine what makes the shapes you see—a rock the water flows around or one just under the surface, a shallow riffle. In this demonstration, the shapes were made by a rocky incline where a bridge used to be.

Materials

1" (2.5cm) flat brush, no. 8 round brush, assorted watercolor pigments, graphite pencil, watercolor sketchbook or journal

1 Capture the Image
Take a picture of the area you'd like to paint for later reference.

2 Draw the Water
Draw a few sketches of the surrounding water to get a feel for the way it flows.

3 Add Final Details
I sat on the bank and painted after getting into a zen place with my sketches. You can see my simple kit right by my journal.

Photos vs. In the Moment

This is why I enjoy working on the spot much more than working from a photo. Here the bright sunshine throws the stonework on the far bank in almost-black shadow and the foreground is too dark to be interesting. Sitting on the bank, I could see all the detail and nuances, and choose which to include.

Remember, in still water or large bodies of water, the distant horizon is generally a straight line parallel to the top of your page. Water seeks its own level, so if you're painting the ocean, a lake, your own pond or even a broad river with a distant shore, remember that shoreline or horizon will be level, too.

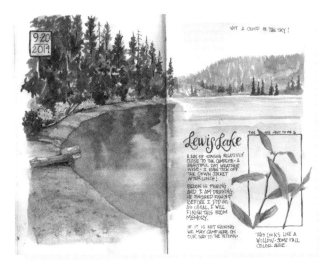

Still Water's Horizon Line

Still water is a challenge that requires you to remember that flat horizon line or distant bank. Trees may be softly reflected color, as Gay Kraeger has done here with a breeze. She does this by making linear streaks in the water on the right, where it's unprotected by the tall green trees.

Reflections

When reflections occur in still water, mirror the shape or position of what casts them. If a tree leans to the right, so will its reflection. It will also appear clearer the closer it is to the tree, and then become a calligraphic scribble as it branches away from the tree. A few horizontal lines across the reflection reinforce the impression of limpid water, when using a linear medium. I used a bent-nib calligraphy pen to accomplish this reflective sketch.

Negative Shapes

You don't always have to portray the water itself. Laura Murphy Frankstone has let the shape and positions of the rocks tell us about the bay in this fast sketch—they act as negative shapes that tell the watery story.

Find Water

Wherever you are, find water! Sit and take a long look, think about how long you have to work and how that affects the medium you'll choose or your working method. Consider how you want to place your subject on your paper, and what format you want to use, horizontal, vertical or square.

Do a small sketch first. It helps to map the shape of the river or lake, or capture moving water like rapids or a waterfall. Make a graphite guideline if you feel the need.

Trees

When we're young we draw shorthand trees, a child's green lollipop on a brown stick. When you look around with the intention to really *see*, you'll find many different shapes even within the same species. That's one thing that makes trees a favorite subject: they're always beautiful and challenging.

Trees of some sort are present in almost any landscape you may encounter. You'll find pine trees, palms, apple trees, cedars, hardy oaks, tall poplars or graceful willows. As you look carefully at each one, you'll see how the individual shapes and foliage tell us the tree's identity, as well as something of its growing needs or condition.

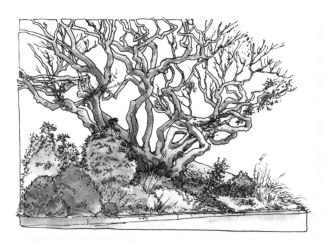

Bones of a Tree

In winter you'll be able to see the bones of the tree. Notice how the size goes from the trunk (largest) to branches, limbs and twigs (smallest). Warren Ludwig has captured a very specific tree by paying attention to these things, as well as the position of each limb. Notice the overlapping shapes; these negative shapes between the branches help catch the perspective.

Gnarled Tree

Find a bare tree in winter (or perhaps a dead one if it's summer), and sit comfortably nearby. Pay attention to its now-exposed growing pattern of trunk, branch and twig. Utilize overlapping shapes and suggest bark texture, if you have time. Use whatever medium suits your mood and the subject.

If there's a tree that especially catches your eye, like this lightning-damaged oak, take time to observe and draw the shapes and textures. Splash in a background and leave the tree as a line drawing, as I did here. Wet-in-wet blending and a bit of spatter suggest the light-dappled forest beyond.

Tree Species

Take a half hour or so to walk around your area, wherever you are. Notice the variety of tree shapes and look for different types or species. Do quick sketches to help you identify them. Simple silhouettes like these will show you a lot. Identify as many as you can to truly get to know your area.

Textures and Foliage

Trees only blend into a single shape from a distance, but even then there's usually some variation in texture or color that makes the image more interesting. Look for ways to suggest distance.

Textured Trees

Don Gore used a single ink pen to express the gestalt of these evergreen trees. The spiky, scratchy feeling is perfect for their texture.

Quick Marks

Let your brush marks suggest the foliage of specific trees. Shevaun Doherty captured the feel of olive trees with hundreds of small, quick marks, and carefully observed the growing patterns, as well.

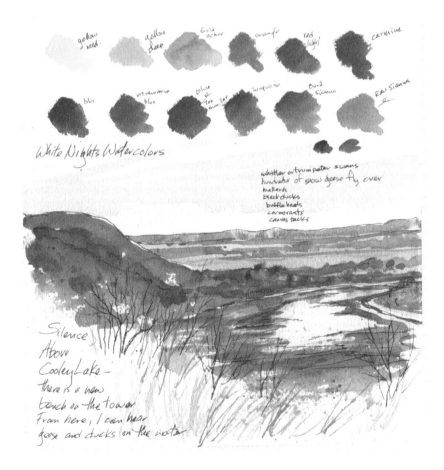

Tree Details

I often make my pages do double duty. Here, I was trying out new paints (at the top) but didn't want to waste the page. A trip to Cooley Lake tempted me to paint that simple blue distance. The hill to the left was much closer, so I used texture and variation in color to suggest the trees there, and the bare winter trees in the foreground got a simplified but more detailed handling to bring them forward.

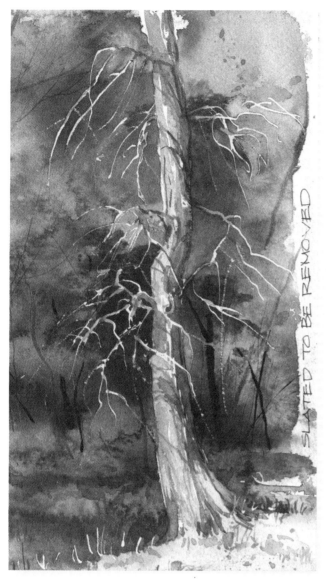

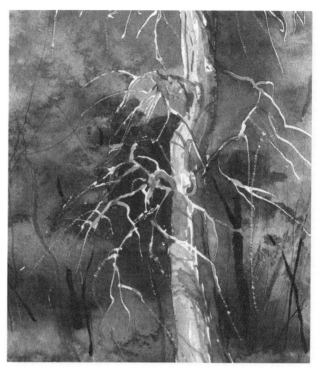

Forest Details

I didn't create much detail in the background, only enough to suggest the idea of forest. Spatter, scraping and a few tree trunks let the foreground tree pop.

Masking

Carrying masking fluid in the field can be tricky, but some companies make a needle-point applicator that makes it a lot easier and safer. (I once turned a whole bottle of the stuff over on the rocks I was painting!) Here, I protected the fine limbs of the dead tree, and painted in the background loosely. When that was dry, I removed the mask, painted the trunk and softened some of the limbs with clear water so they didn't look so pasted on. Then I scratched out even finer twigs with a sharp blade.

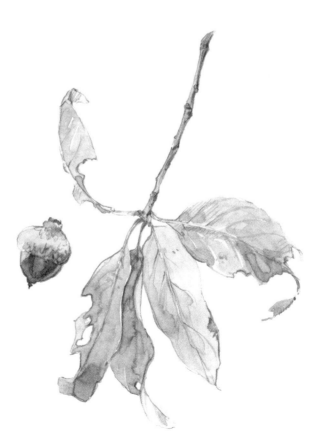

Leaf Details

If you prefer, sketch a detail you may find at your feet, like this twig, leaf and acorn from an oak. Take as long as you want.

Hills, Mountains and Rocks

You may want to try to sketch what you see as closely as possible, and light can make a big difference here. Hills and mountains in the distance may appear higher, simpler, smaller and, if you're working in color, perhaps bluer or cooler as well.

You can utilize this aerial perspective to give your sketches a sense of depth. Choose your medium to go with the subject or with the amount of time you have. Play with color and texture to express what you feel about the landscape. Take a peek at how Canadian artist Marc Taro Holmes interpreted Sugar Loaf in Rio de Janiero, and then how Australian Liz Steel sketched the same subject. The styles are different, but both captured the feeling beautifully.

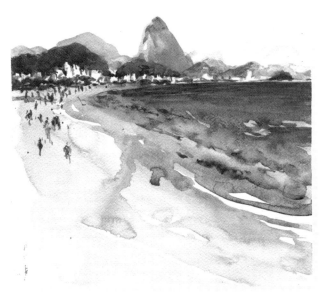

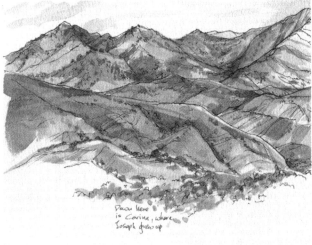

Underdrawing

Marc Taro Holmes used very little pencil underdrawing (if any at all) in his quick interpretation of Sugar Loaf.

Linework

I chose to use a lot of linework to suggest the ruggedness and eroded peaks of the San Gabriels in California before I added watercolor washes. I took my time and paid attention to the planes and textures I saw across the valley.

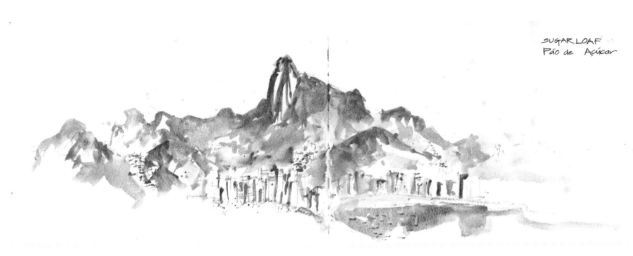

Guideline

Liz Steel used just a bit of brown ink as a guideline and then splashed in color freely. Notice how she suggested the skyscrapers and other buildings at the water's edge.

And, of course, there are exceptions to any rule (they really are only guidelines when it comes to art). No one can tell you what you should sketch, or how. Let your eyes and your soul drink in the scene, and respond from your heart, not your head.

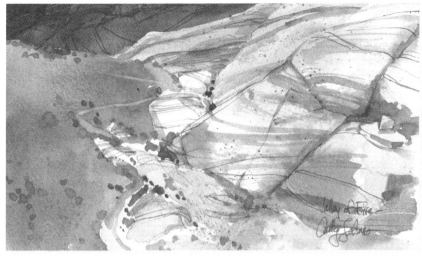

Texture

Explore ways to express texture. Your paper surface can help with this. Explore a rough paper if you want to depict a rugged surface. Use a dry brush in watercolor or skim the high points of the paper's surface with colored pencil or graphite. Values create the illusion of volume and shadow.

Hill and Rock Shadows

I felt the need to zero-in on the mammoth Nevada rocks while the farther hill was in shadow. To capture some of the linear aspects of rocks in The Valley of Fire, I used my brush with the sharpened end, dipped it in a strong wash of color and drew with it. An old bristle brush, meant for oil paints, worked well to spatter some additional texture.

Demonstration

Depicting Rocks

Try to capture the volume, as well as the color and texture of rocks. These are big, round boulders, which are quite different from the desert sandstone shown above.

Materials
paper with a bit of texture, wax-based colored pencil (like Prismacolor)

1 Capture the Image
I used a black wax-based colored pencil with no underdrawing to suggest the texture of this boulder.

2 Add Watercolor
I added watercolor washes directly over a colored-pencil drawing to create color and volume.

3 Create Texture
Alternately, I skimmed a dry brush over the surface to catch the feeling of rough texture.

Skies and Clouds

Don't forget to look up! Clouds make for an interesting and active sky. They move and change, and follow the rules of aerial perspective, in reverse. Clouds that are closer to you appear at the top of the picture plane and appear larger. As they recede into the distance, they often appear smaller and flatter.

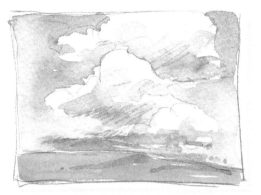

Thumbnail

To get a handle on what you're seeing, try a small thumbnail sketch. It reminded me of all I needed to know about this particular cloud formation.

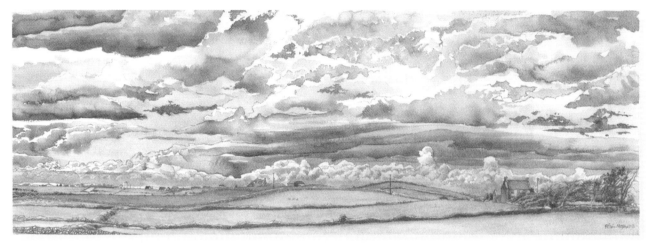

Complex Clouds

Ireland is often blanketed with gorgeous, complex clouds. Róisín Curé took her time to fully explore the sky above these Galway fields in pencil and watercolor.

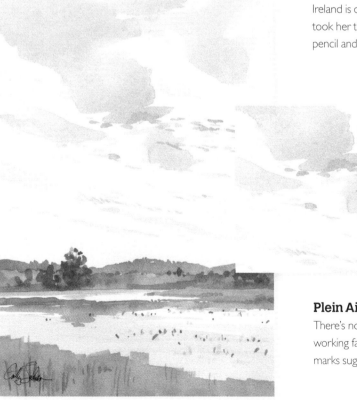

Detail

Take a look at this close-up. By itself it may not read as clouds and sky, but in context it gets the idea of a high summer sky across.

Plein Air Clouds

There's no need to do a careful cloud portrait if time is short. I was working fast on this sketch, and a series of small, quick washes and marks suggest the clouds and the spaces between them.

Plants and Flowers

Sometimes we discover a more intimate look at nature right at our feet. Plants, flowers, seeds, mushrooms and pine cones are all fascinating sketching subjects—it's a magic world in miniature.

How do the leaves grow? How are they shaped? What form does the flower have? What did that seed come from? What kind of moss or mushroom is that? Make written notes of any observations as you go along and you'll find it easier to identify an unfamiliar flower.

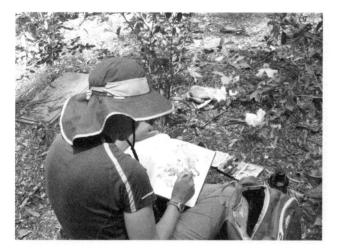

Finding Treasures

Nina Khashchina gets right down to ground level to find the plants and other treasures she and her son observe on their walks.

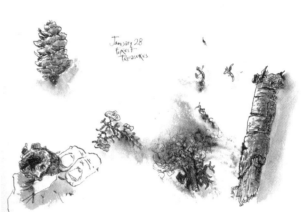

Drawing in Perspective

Here, Nina has sketched lichen, moss, a pine cone and a twig keeping the appropriate perspective and size in mind.

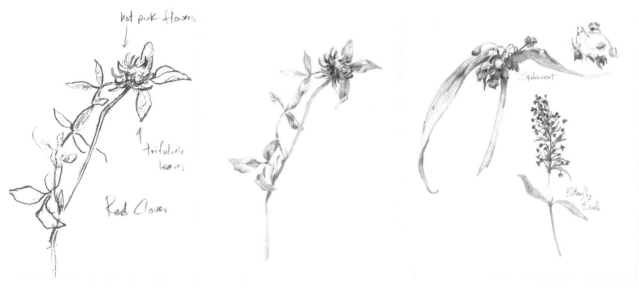

Familiar Fauna

Even the most familiar, common flowers are worth your attention. I got nose-to-nose with this red clover. A quick gesture sketch was enough to tell me I wanted to explore further.

Backyard Explorations

Why not explore your own backyard and get to know the weeds or wildflowers you find there? Do a fast sketch or take your time and enjoy a meditative drawing. Imagine yourself as a botanist or an herbalist of the old school.

Wildlife

It can be difficult to get close enough to birds to really see well enough to sketch them. As noted previously, John Muir Laws uses a telescope. You can use a blind to observe birds without letting them see you.

I often sketch from my car. Wild birds don't seem to feel threatened by someone in a car, but if I get out to come closer, they are liable to slowly move away or fly off altogether. If you have feeders, backyard birds may be accustomed to being watched. Whatever it takes, practice working fast—you may need it!

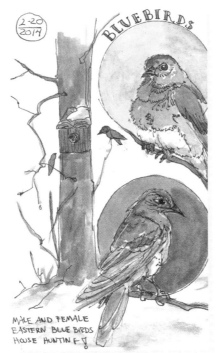

Draw Common Birds

You can celebrate the more common birds, too, as Jan Blencowe did here. I always delight in the first bluebird sightings of the year.

Draw Backyard Birds

I've seen some amazing birds in my own backyard. One of my favorites was a huge pileated woodpecker. I was told they don't come to feeders, but no one told this guy!

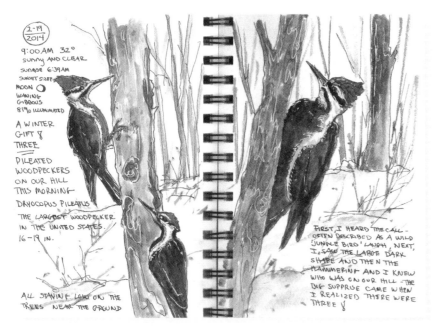

Draw Local Birds

Jan Blencowe saw three of these North American woodpeckers in her woods and created a wonderful journal spread. Take advantage of these natural serendipities and create a lasting record for yourself—it's important!

Demonstration

Sparrow

I couldn't really tell what this little brown bird was until
I got out my binoculars. I just knew it was some kind of
sparrow. The yellow spots on his white eye-stripes told me
he was a white-throated sparrow.

Materials

assorted watercolor pigments, graphite pencil,
ink pen with black ink, smooth watercolor
paper

1 Create a Thumbnail
I drew a quick shape in pencil.

2 Ink the Image
I drew on top of the pencil guidelines
with basic ink outlines. When that was
dry, I erased whatever pencil lines were
still showing.

3 Apply Washes
I added the first light watercolor
washes, using a varied gray to keep it
more interesting.

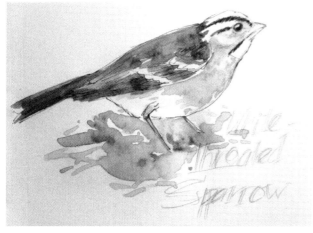

4 Apply Brighter Washes
The brown wash for the sparrow's back was next, then the
spot of bright, unsullied yellow next to its beak.

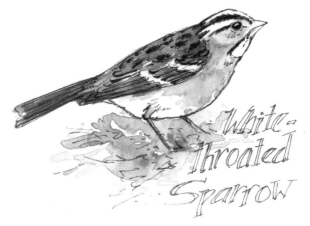

5 Add Final Details
Finally, when the wash was dry, I added the additional
patterning in his feathers. I wrote his name in ink and called
him done.

Birds in the Distance

You may see birds only in the distance, but they can still give your sketch a sense of life. I remember discovering Frederick Franck's lovely, evocative drawings and noticing how he let dashes and dots suggest the birds he saw in a landscape. I've used a similar effect here.

Materials

1" (2.5cm) flat brush, no. 8 round brush with a sharpened end, assorted watercolor pigments, black ink pen, white gel pen, textured watercolor paper

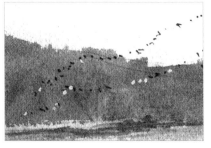

1 Suggest Trees
I let the texture of the paper aid me in suggesting lacy trees in the background by skimming my almost-dry brush across the surface.

2 Add Birds
After I got home, I used a white gel pen to add more snow geese by placing dots and dashes against the dark hill.

3 Splatter Paint
A little wet-in-wet work and spatter gave texture to the foreground.

4 Add Ink
Sharp touches of ink made the foreground details crisp and brought them forward.

5 Add Final Details
I used the end of my brush to draw in the tree branches and the geese in the sky.

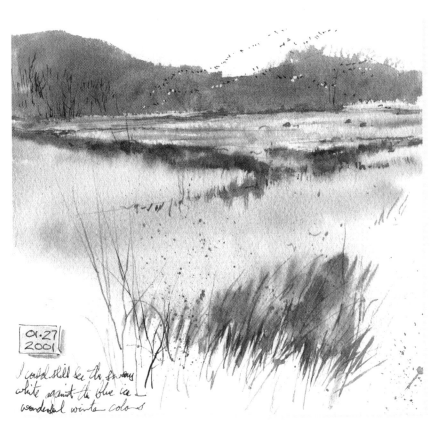

01.27
2001

I could still see the snowy
white against the blue ice —
wonderful winter colors

Field Journal Pages

I love to make my own field journal pages, whether at home or abroad. Getting to know the area more intimately and understanding cause and effect in a given biosystem are two of the best reasons to sketch on the spot. Written notes, observations and a little habitat sketch help us learn more about where we find ourselves.

Special equipment is not necessary, but as you find yourself working outdoors more often, your curiosity may be piqued by things that are difficult to see with the naked eye. Either you'd like to see those distant birds more clearly and binoculars or a telescope may help, or you wonder what that tiny bit of lichen would look like if you could see it better. A small magnifying glass may be all you need, but you can buy a fairly inexpensive hand microscope at science stores and some sporting goods stores.

Binoculars can boost your vision many times over. Serious birders may need the big guns, but take a peek at what's out there; you may be happy with a much less expensive, lightweight unit. (Be aware that it's sometimes difficult to draw while holding up binoculars, so you will need to train your memory.)

I also have a small digital camera that works well to bring things closer. I occasionally need to shoot photos and work from them later, but I also shoot with an optical zoom, then zoom in again on the viewscreen and sketch distant details right then and there.

John Muir Laws has a telescope set up on a tripod, as you saw earlier in this chapter. Many serious outdoor nature painters do. It all depends on how much gear you want to carry into the field. Again, take weight into consideration if you're going to walk far.

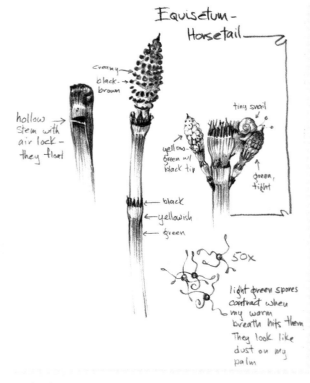

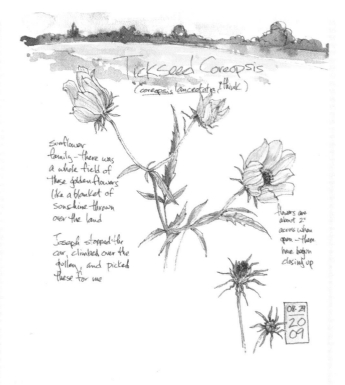

Hand Microscope

Equisetum, or horsetail, grows wild in damp places, so I took my hand microscope into the field with me. This graphite drawing was done with an HB mechanical pencil. The fine point allowed me to zero-in on the detail.

Too Far Away

I noticed a gloriously golden field by the highway, but we were too far away to tell which member of the sunflower family we saw. My husband climbed over the gully to pick a few for me to study. I was able to ID Tickseed Coreopsis and made this ink and watercolor sketch.

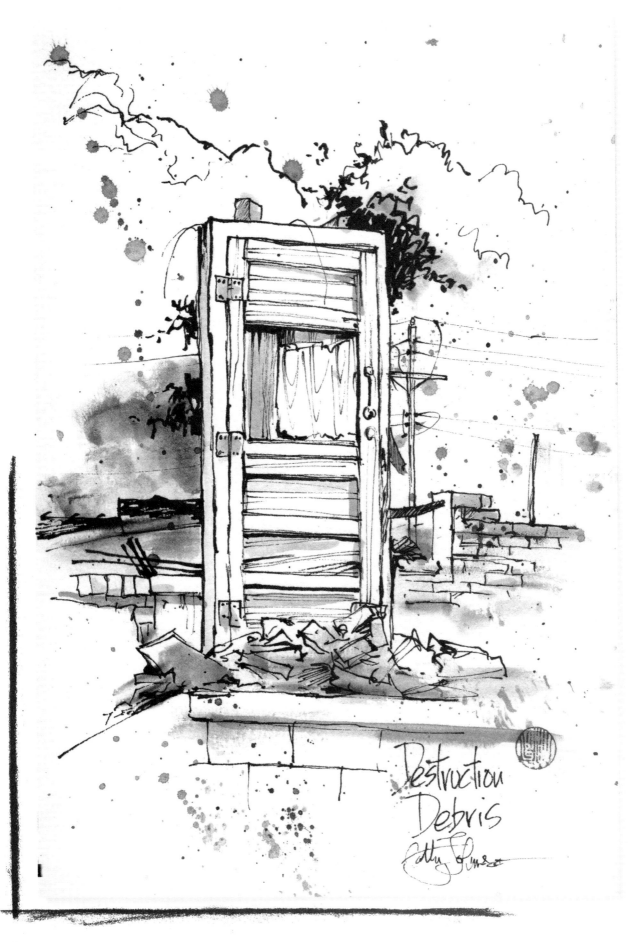

Destruction
Debris

Urban Sketching

These days, it seems as if every other art book or magazine article is on urban sketching! The practice has grown explosively in the past few years. Every city and town seems to have its urban sketchers group, and ours is no exception. It's fun, challenging and fascinating. It tells a story. It's a record of the way things are, this very day, right where we are.

Finding a subject is easy, if you keep an open mind. Urban sketching is about far more than architecture, though buildings are certainly part of it. It's also about life. Reality. Details. Action. History. People. Change.

Sometimes my favorite sketches are just that, a record of change as buildings are torn down and bridges are replaced by safer, albeit less picturesque, modern ones. Grab a pen or pencil and document the changes.

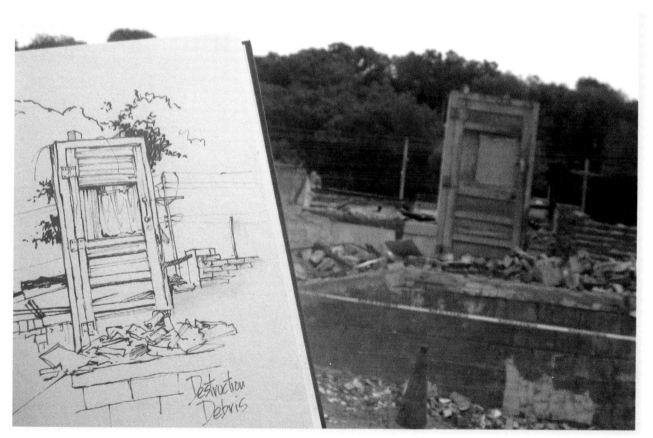

Destruction Doorway

The old laundry that had employed generations in our town finally met its destiny with the wrecking ball. I was amazed that the steel-reinforced door was still standing when all else was rubble, and I couldn't resist stopping by the side of the road to sketch it with my bent-nib calligraphy pen and black ink. I diluted more ink to add a bit of shading and some spatter.

Documenting a Place Over Time

Stockholm's Nina Johansson draws her urban locale, year-round. One of the most fascinating areas she has captured is Slussen.

Her written notes are in Swedish, but her images speak for themselves. Here are some of her compelling sketches, and an explanation in her own words.

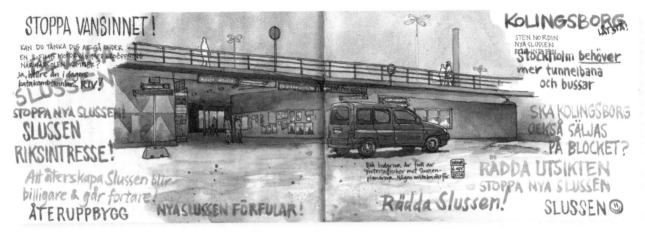

Complexity

Feel free to add text to your sketches. Observations, overhead snippets and slogans like these can add a lot to mood as well as provide information and graphic energy.

"I draw a lot at a place called Slussen in Stockholm, a complex construction which is a bridge, a water sluice and a big traffic hub all at the same time. It's a place full of tunnels, walkways and underground tracks, and there are people moving through it constantly. Lots of commuters pass through here every day, and since the city decided to demolish it years ago, the discussions have been vivid among both politicians and Stockholm's inhabitants; protests have been held both for and against the plans for New Slussen."

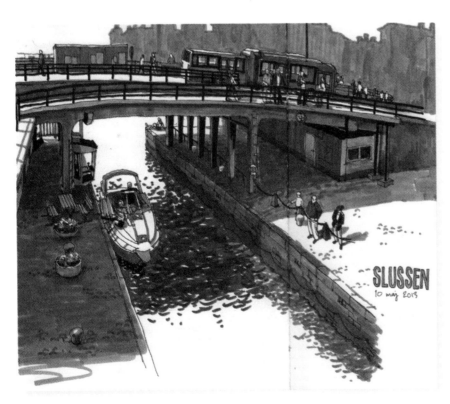

Change and Decay

A combination of ink and grayscale markers suggests mood and pulls areas of the composition together.

"Because of the building plans, the place has been badly neglected for years; it is quite dilapidated in many places. This is an unusual sight in Stockholm, a city that is very polished and shows a pretty surface almost everywhere these days, which is part of why I like drawing at Slussen. Also, I find it incredibly interesting to document the same place over. The process of change and decay is as interesting as the people who pass through here every day."

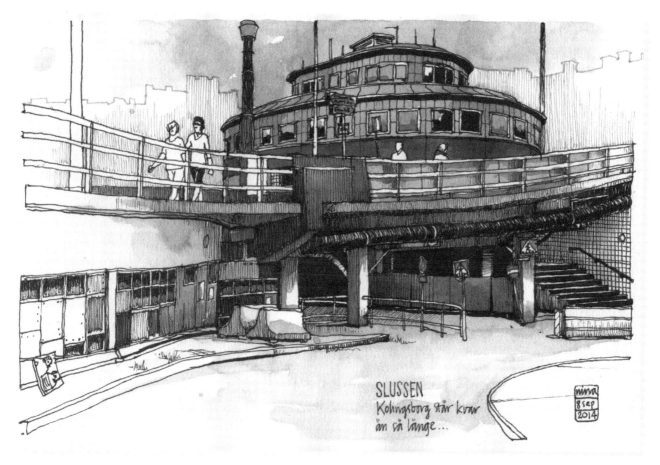

Color and Grayscale

"I try to vary my choice of techniques when I draw here. Slussen is a pretty gray place with all the concrete, but with a beautiful play of light everywhere on a sunny day. So both color techniques and grayscale work fine here."

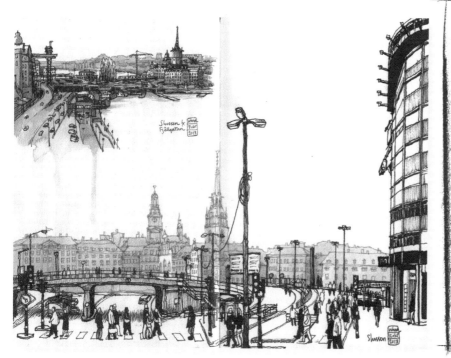

Exercise

Identify a building or area that's about to be demolished or looks in danger of it. Your city government will have a list of buildings slated for demolition, or simply zero-in on one that looks dilapidated. Find a good place to work and visit it weekly or monthly to capture the progress. Of course, in some cases, a bulldozer will make quick work of removing a small house, so draw fast and stay out of the way of heavy machinery! If a foreman tells you to move, do it!

Details and Scale

An ink pen with a fine nib works well for capturing details, no matter where you sketch. Add people for scale.

95

Grain Elevator

Sketching often involves being at the right place at the right time. You may drive by just in time to see the action, so be prepared and always have a small sketch kit with you. I keep my journal and a simple watercolor kit with me, so I was prepared to stop and sketch the grain elevator demolition as we drove into Kansas City one day.

The juxtaposition of the geometric shapes of the old ConAgra grain elevator, the cylinders and rectangles of the original building, and the almost organic, calligraphic effect of steel girders and reinforcements was just too interesting to pass up. The strong winter sunlight and warm and cool colors made it all the more dramatic. I stayed in my car and out of the way of the bulldozers, sketching through the windshield.

Materials

assorted watercolor pigments, graphite pencil, hot-pressed watercolor paper (or journal or sketchbook), water source

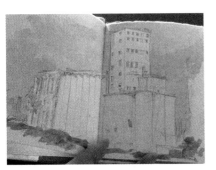

1 Draw the Building

I sketched the building and applied the first wash for a strong blue sky.

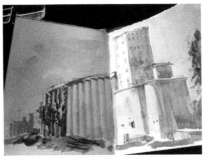

2 Add Warm Washes

I added warm washes on the buildings themselves, then more detail as that area dried.

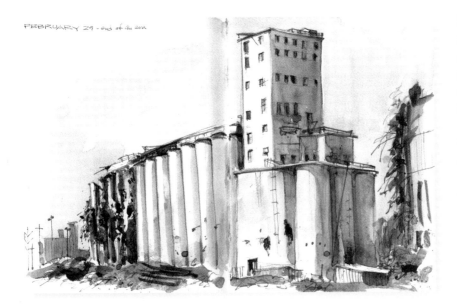

Ink and Watercolor

Ink and watercolor is popular with many sketchers, whatever the subject. It gives us a guideline—the bones of a drawing—and we can flesh it out as we wish, perhaps splashing in color more spontaneously.

Many people feel that drawing in ink helps them to slow down, observe more closely and commit. It's your choice, as always. A few weeks later, all that was left was one triangular form, a pile of rubble and a Medusa-like tangle of reinforcing rods.

Stone Building

Sometimes change is in usage, not in decay or destruction. A charming stone building in our town used to be a funeral home and chapel. At one time it was to be a restaurant and a cooking school, and now it's waiting for a new buyer with a vision and a plan!

Materials
assorted watercolor pigments, hot-pressed watercolor paper, ink pen with a flexible nib

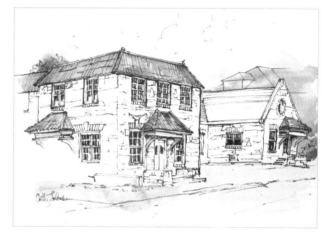

1 Draw and Ink the Image
I was going for a combination of unfinished areas and more detail, and I planned to let my later washes follow that same pattern. I applied black ink with a flex-nib fountain pen to suggest the texture of the stonework and the tile roof. It's not necessary to draw every stone; a few marks will tell the story. Let the ink dry thoroughly before adding color.

2 Apply Washes
I added the first loose, light watercolor washes in the sky, the grass and the red tile roofs. I kept the distant buildings simple and used a blue-gray wash to push them into the background.

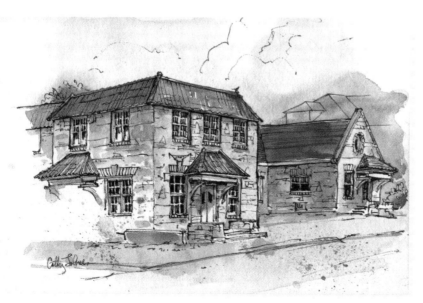

3 Add Final Washes
I added various warm and cool gray washes and allowed them to mix on the page before adding spatter. These washes stand in for the stonework, and the spatter offers some texture and spontaneity.

Inside, Outside

Museums and other public buildings are wonderful places to sketch, whether indoors or out. Kansas City's Nelson Gallery of Art is full of inspiration, from the huge shuttlecocks on the sweeping lawns to one of the finest collections of Asian art in the world. Whether you visit alone or with a group of other sketchers, you will find plenty to make your fingers itch to draw.

Like many museums, the Nelson asks you not to use ink inside the gallery, but they actually provide free pencils to encourage sketching and note taking!

The Great Indoors

You can find something to draw almost anywhere, indoors or out, and sometimes it's hard to tell which is which! Our huge sporting goods store has a waterfall in the middle of it, with mounted wildlife perched on the stones and live ducks and fish swimming in the pool at its base. Crown Center in Kansas City sports a waterfall, as well, on what used to be the natural limestone bluffs that now overlook the lobby of a modern hotel.

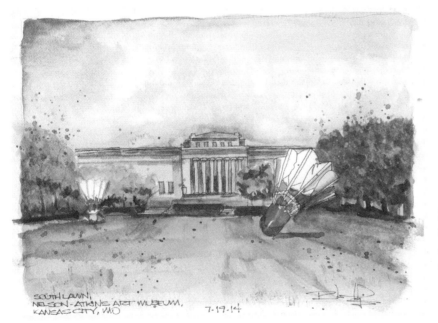

Famous Outdoors

St. Louis artist Steve Penberthy worked outdoors so he could use brilliant watercolors to paint the famous shuttlecocks, which were designed by Claes Oldenburg and Coosje van Bruggen.

Cuan Yin at the Nelson — a serene and compassionate countenance

Quan Yin

I often find myself parked in front of the massive statue of Quan Yin. Since I was working inside the gallery, I drew this serene presence in pencil only. When I returned home I added loose washes, wet-in-wet.

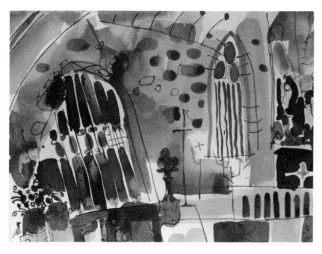

Dancing Brushes

No need to approach your subject in a traditional manner. Let your brush dance and your colors sing, as British artist Sue Hodnett did here.

Add Notes

Don't hesitate to add notes to your drawings. These can be traditional artist's color notes, field notes, a little poetry, a grocery list, a phone number, memory aids, impressions—these are your sketches, to do with as you feel the need. The written notes often can add a lot, capturing something ephemeral as well as providing a strong graphic. Use a larger pen or brush and make a headline!

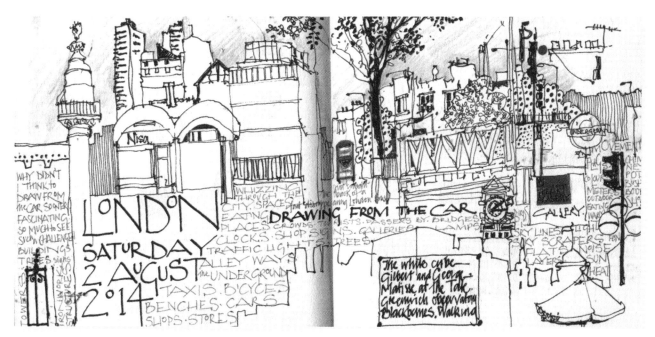

Calligraphy Notes

Pat Southern-Pearce captures some of the energetic, busy feeling of a day in London with the copious calligraphic notes that add so much to her work. Every inch is delightful, inviting us to browse through the pages for as long as we wish.

Statues and Public Art

Statues are like models that hold still indefinitely. You can study human form, action, expression, the effects of light and shadow, and volume while exploring public art. Work fast or slow, however you like, depending on how much time you have or how complex the subject is.

And, of course, not all statues are of people. Think of Henry Moore's massive sheep sculptures or Picasso's colorful abstract shapes. They're fun and challenging to draw, and they capture the essence of the area where you find yourself.

Often, you can research interesting tales of the installation of more controversial pieces. The Shuttlecocks that Steve Penberthy sketched (on page 98) are one case in point. I love the whimsy of the idea that the Nelson Gallery is a giant badminton net, but some felt the idea wasn't sufficiently serious for the venerable art museum.

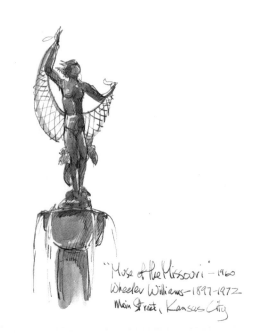

"Muse of the Missouri" - 1960
Wheeler Williams - 1897-1972
Main Street, Kansas City

Basic Pose

At a downtown intersection, I had only a brief time to sketch this statue. It was enough time to capture the basic pose in ink, so I waited until later to lay in the colors of weathered bronze.

Get Some Perspective

Consider sketching statues from more than one perspective. Check out the back, get close and look up at an extreme angle, focus on a detail, try different materials or techniques. Take full advantage of this stationary subject!

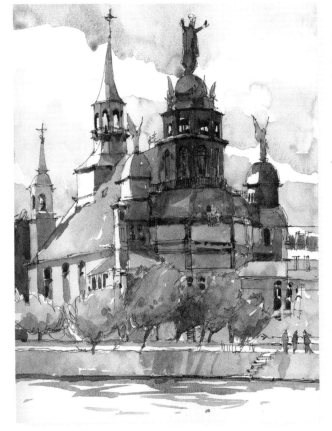

Complements

Distant sculptures can be simplified forms that complement architectural studies, like Shari Blaukopf's Notre Dame de Bonsecours.

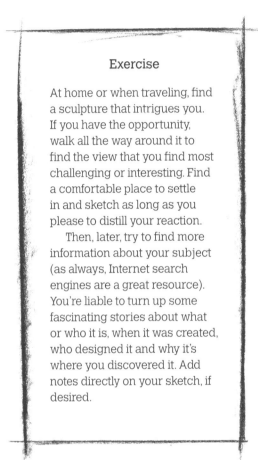

Futuristic

Futuristic forms loom over Kansas City's Bartle Hall Convention Center, somehow reminding me of the old Hanna-Barbera TV show, *The Jetsons*. I didn't leave room for all four pylons on my page, so I added a detail of the closest one, larger. It's good to plan ahead, but if you goof it's not a disaster, either.

I should have started with this one

over the hill loom those futuristic sculptures you either love or hate

Bartle Hall, Kansas City

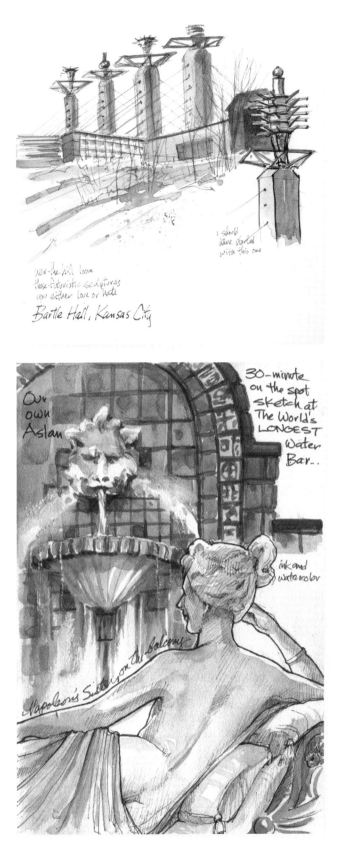

Our own Aslan

30-minute on the spot sketch at The World's LONGEST Water Bar..

ink and watercolor

Napoleon's Sister on the balcony

Exercise

At home or when traveling, find a sculpture that intrigues you. If you have the opportunity, walk all the way around it to find the view that you find most challenging or interesting. Find a comfortable place to settle in and sketch as long as you please to distill your reaction.

Then, later, try to find more information about your subject (as always, Internet search engines are a great resource). You're liable to turn up some fascinating stories about what or who it is, when it was created, who designed it and why it's where you discovered it. Add notes directly on your sketch, if desired.

Marble

There has been a marble sculpture of Marie Pauline Bonaparte, sister of Napoleon, in our Hall of Waters (now City Hall) for years. For a long time she was relegated to storage or hidden on the second floor for being scandalously undressed, but she's back on the ground floor, lovely as ever.

Street Scenes

Street scenes are great fun to sketch, and they often capture the essence of a place. Draw from above, from a window or balcony, sit in a sidewalk café, hunker down on the curb—whatever you do, see if you can zero-in on what it is about the place that makes it unique.

Moody Feel

Canadienne Shari Blaukopf catches the clean lines and moody feeling of a cloudy day in her city.

Bustle

Choose your format to fit your subject as well. Don Low chose an extreme vertical format for this narrow street, and we feel the bustle of the city all round us.

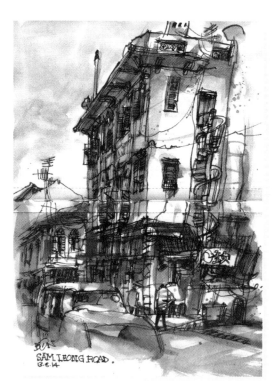

Busy

Don's *Sam Leong Road in Singapore* feels much busier and more active. You can match your style to the feeling you're after.

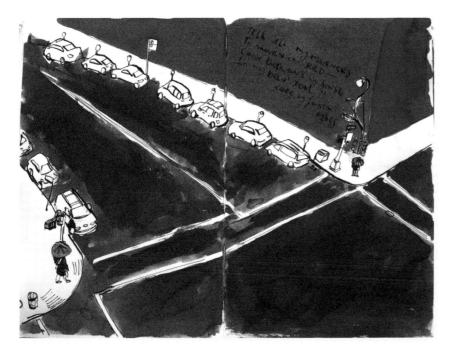

A Sense of Scale

Danny Gregory chose a bird's-eye view and bright, graphic colors to capture the street scene far below. The cars give a sense of scale.

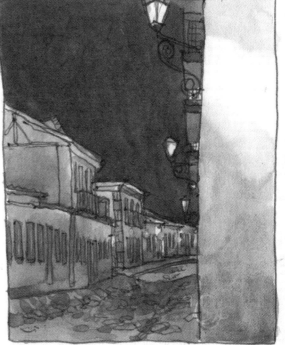

26 aug 2014 Paraty, Brasilien

A Sense of Calm

I sketched from the top floor of North Kansas City Hospital one April day to keep myself calm while my husband was in recovery after surgery. It was a fascinating and challenging view of the old rail yards and streets.

Nighttime

Try capturing the feeling of a city at night, as Nina Johansson did in Paraty, Brazil.

Markets

This is a great chance to capture the busy life of a city or the lonely feeling of a market in the off season. In the growing season, colorful vegetables and fruits vie with the color of the sellers, as well. Our big city market in Kansas City is busy on weekends, with all kinds of vendors and shoppers, as well as live entertainment. Small farmers' markets in rural towns still provide dozens of great subjects—even live chickens and fresh eggs.

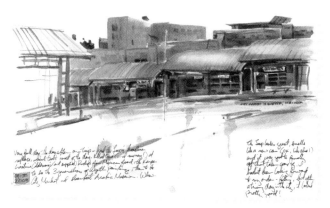

Rainy Day
The market is quiet on a rainy weekday. We parked across the street and I sketched the long market stalls that bustle with activity on weekends.

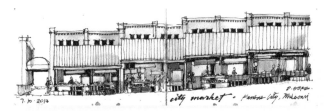

Same But Different
Don Gore's ink-and-watercolor version of the same market is colorful and inviting. He used a simplified, stylized technique that helps bring order to a sometimes overwhelming subject.

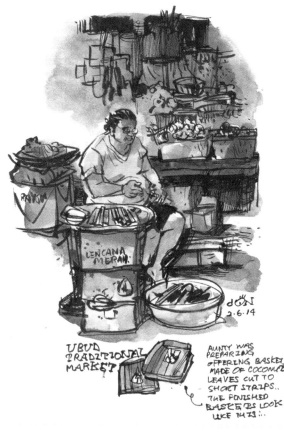

Traditional
Don Low captures one of the sellers in a traditional market in Bali, as well as her wares, using brush pen and watercolor.

Busy Bees

In a busy market, finding someplace you won't be tripped over is sometimes a challenge! This may be a good place to carry your lightweight sketch stool with you, since available benches may already be taken by shoppers laden with purchases and young children.

Restaurants, Cafés, Wineries and Bars

These are some of the favorite and most challenging subjects for urban sketchers. People come and go, the food arrives, we chat to one another and juggle forks and plates and drinks and ink pens, trying not to spill on our sketchbooks, but the effect is almost always worth the effort.

Don't be intimidated. As suggested earlier, a corner booth or a table off to the side may give you more room and let you feel less exposed as you sketch. You'll usually have a comfortable place to sit and a flat surface to work on—that can be a huge bonus.

Other diners seldom notice you're sketching unless you have your gear spread out all over the place. It's fun trying to capture the infinite variety of their poses.

Breakfast Sketching

Liz Steel visited us in Kansas City, and we all enjoyed our stay at the historic Savoy Hotel. The breakfast was well worth a sketch, and, of course, I added Liz and her little travel companion, Borromini Bear. He's been drawn all over the world as he accompanies the peripatetic artist.

Odds and Ends

Look around when you're in a restaurant or pub, and you may be surprised at some of the sketching opportunities. The Westport Flea Market Bar and Grill boasts the Burgermobile, which is worth the time to sketch any day, as soon as you quit laughing. And just think how many bars have mounted jackalopes on the wall. I've sketched one before, how about you?

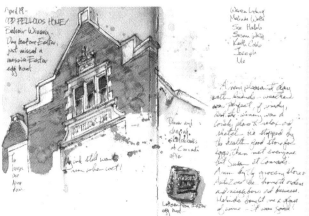

Wining Down

We've had several sketchcrawls at local wineries. They're delightful places to sit and sip while drawing. Many wineries are in picturesque spots or old buildings. This is the former Odd Fellows Home in Liberty, Missouri, now Belvoir Winery. It's good to see formerly abandoned buildings put to new use, and I'm always happy to document.

Sketching Food

If you're sketching your food—and a lot of us do—you may want to jot down a quick pen or pencil sketch and add color later so your meal doesn't get cold (or order something cold in the first place).

At Home and Abroad

It's interesting to note similarities in urban areas around the world. As you find more sketches of these populated areas in books or online, you may be reminded of something you've seen in your own area and decide to explore the similarities. Capital domes are often similar around the world. Amphitheaters and band shells are similar in shape, if not design. A small stone church in the Midwest may remind you of a similar one a friend drew in Ireland. It's fun to capture those visual and emotional connections when you notice them!

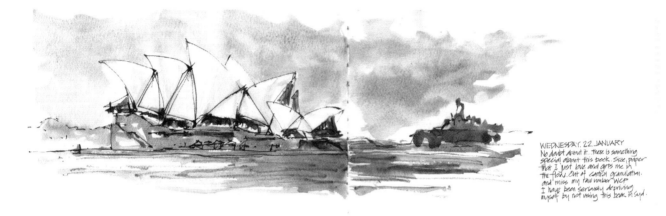

Iconic Sketch

Who wouldn't be struck by Liz Steel's fresh, iconic sketch of the Sydney, Australia, opera house? It's an unforgettable image.

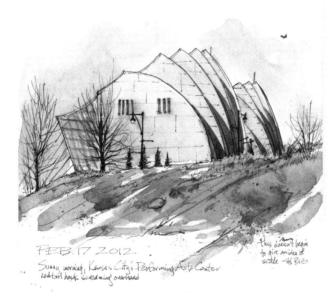

Different Styles

When I saw the sweeping, rounded shapes of the Kaufman Center for Performing Arts in Kansas City, I couldn't help thinking of Liz's sketch of a building with similar curves—though mine is much tighter. We all have different styles.

Flesh Out

Mark Holmes used a few lightning-fast pencil lines to capture the poses of these historical reenactors in New France. He knew he could flesh them out later with watercolor washes.

Adding People

Your sketches don't need to be devoid of life. Cars, shoppers, participants, re-enactors and performers all add a lot. It needn't be daunting, and you don't have to strictly stick with portraits.

Practice sketching people in public places. It's not necessary to make your sketches recognizable as any particular person. In fact, it's probably best not to. As stated before, you can sketch when people aren't watching; wear sunglasses or just glance, don't stare. Work fast, if you need to. Sketch from a distance or from the back, just going for gesture or pose. Simplify and remember to have fun!

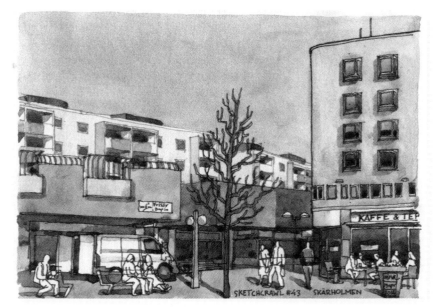

Simple Human Shapes
Nina Johansson adds the simplest of human shapes to her urban sketch, but notice how it brings the scene to life.

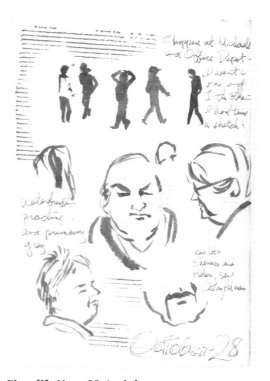

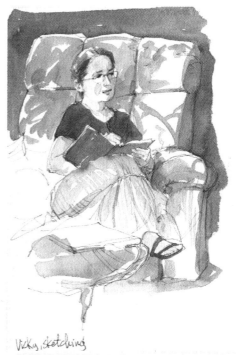

Simplify Your Materials
I used a waterbrush loaded with diluted ink for this exercise, keeping it very simple.

Willing Models
Draw fellow sketchers for some wonderful practice—they're usually more open to it. This is Vicky Williamson at a sketchcrawl.

Christmas Day, 2007 —
up on the hill with Joseph — he is
sleeping sweetly while I sketch the
snowy road by the golf course — lovely cobalt
blue shadows, singing blue sky, rich green and
russet, with a single crow flying over

Sketching Your Life

For me, this may be what sketching on the spot is all about—sketching my day-to-day life. It's certainly what I care about the most. I seldom plan for future paintings these days. I don't take assignments or commissions anymore. Most often, I work in my journal, just for me. It's a celebration, an honoring of the moments of my life and paying more attention.

Interestingly, I find that these very personal sketches—the ones I did because something in the subject spoke to me –are what resonate most truly and deeply with the people I share them with, in person and in my classes or online. They speak with a universal voice. They stir a common memory. We all have a life, we all have our challenges and triumphs and things that touch our hearts. Reducing that to simply manipulating the basic elements to follow the rules of composition or color theory to make a "proper" picture—something to hang on the wall—renders it pretty one-dimensional.

So let's not. There's a time and a place for that, of course, but this isn't it. Let's dig in and see what really matters to us. What speaks to the heart? What's worth the time it takes out of our busy lives? Let's celebrate those small joys, the things that pique our curiosity or stir us to whimsy.

This is not the time for self-criticism, and it's certainly not the time for anyone else to critique. Getting what we feel down on paper is what it's all about.

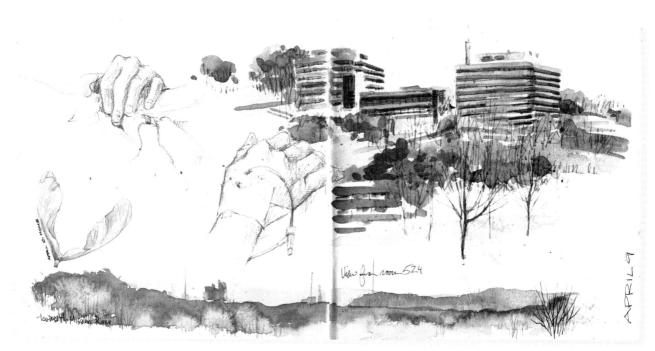

Scary Moments

I've found that even sketching the scary things is precious—later. At the time, the focus on getting them down on paper helps to calm me, center me. My husband was in the hospital for cancer surgery, and doing these sketches helped me immeasurably. (He's fine, now.)

Journaling On the Spot

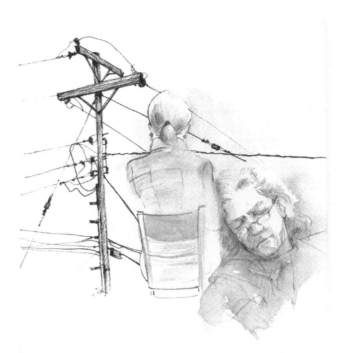

Much of my own sketching on the spot is journal work. One of my most popular recent books is *Artist Journal Workshop*, and I believe that's because the idea of keeping an artist's journal—a true journal, a visual diary—resonates with so many people. It spawned a blog, a Flickr group and a huge Facebook group because the subject speaks to people's hearts.

Sketching on the spot can do the same, depending on what we are doing and why. I need to be out there, I need to respond and explore and celebrate. Other times, when I was working towards a show or an illustration assignment, the energy was just not there. Perhaps you've found the same.

Sometimes sketches are a record of an event or a time in our lives. They can even help us deal with a difficult event or find a new perspective. They can suggest connections you might not even see until they're down on paper!

Exercise

Let your page evolve, adding whatever moves you that day. Take an hour or a day. Then consider what the theme may be, as I did in my Power sketch. Let your images speak to you.

Power

My husband was exhausted after long hours visiting his mother in the hospital. I'd sketched the power lines, then the young woman in her "power suit" and my beloved, who was entirely out of power. I didn't realize until I finished the page what I had done. Each image was done on the spot in a different place, all referencing the same thing.

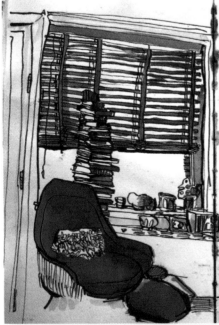

Honesty

Danny Gregory is open and honest in his visual journal, allowing us to follow his train of thought as well as his dancing pen. Reading through the text is a beautiful revelation—let yourself be honest, too. It's healing.

What Matters to You?

Often, artists take workshops, read magazines or page through books that suggest new techniques or approaches. It's inspiring and informative, and I'll freely admit I learned to watercolor from books. John Pike was my mentor and a lovely man. Zoltan Szabo, Milford Zornes, Rex Brandt, Dong Kingman and so many more sparked my imagination and my desire to pick up a brush and try again.

Later, books by people like Burton Silverman, Andrew Wyeth and John Blockley joined my inspirations. I continue to add favorites today. I didn't paint what they painted, but I learned from their approaches and techniques, as I hope you will from this book.

Some people enjoy monthly, weekly or daily challenges where they do their own interpretation of a suggested theme. I'm going to suggest something a bit different. Challenge yourself. The exercises in this book are a good way of doing just that.

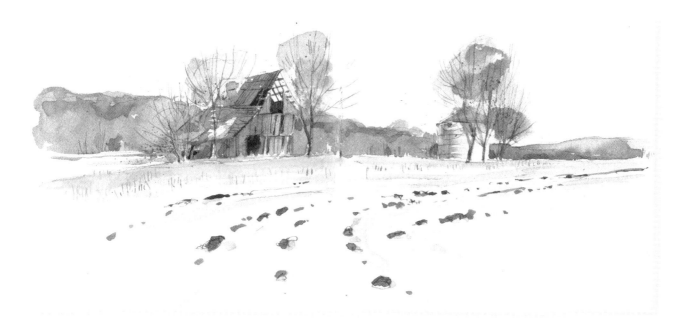

Exercise

Try to remain mindful of your own feelings. Give yourself some time to react. When you're out somewhere, don't jump right into a sketch, but look around and see what really moves you. Ask yourself what you're feeling and why.

If you're at a museum or gathering, or even in your own home, walk around a little until something stops you in your tracks. Hold your hand over it if you wish, or pick it up and see if you can feel any reaction. Does it feel warm and friendly? Uncomfortable? Sweetly sentimental? Do you like or love it? Does it remind you of a wonderful time with a loved one, or a once-in-a-lifetime trip? Sketch that. Explore fully how it makes you feel.

History

Find a place that speaks to your heart. I've painted this old barn any number of times as it slowly returns to the soil. I sat in my Jeep one cold winter day and sketched the barn from the window. As you see, the sketch was both fast and simplified, but it's one of my favorites. It reminds me of my family, full of farmers, and of my own farm, back in the '70s. It recalls history, usefulness, hope, hard work and the simple beauty of these old structures.

Demonstration

Return Sketches

One time, I returned to a nearby site to sketch the Quonset hut and small silo at Cooley Lake. I've been going to this place since long before it was a Missouri Conservation Area; the family still used these wonderful old buildings daily. I've sketched these particular structures three or four times now, always from a slightly different angle. This day, as you can see in the ink-and-wash revision, I considered a view from left front and settled on the view from the right. There's no need to choose the very first thing you see or the first aspect of it. Walk all around, consider front or back, or up close.

Materials

1" (2.5cm) flat brush, no. 8 round brush with a sharpened end, assorted watercolor pigments, calligraphy pen with a flat nib, cold-pressed watercolor paper

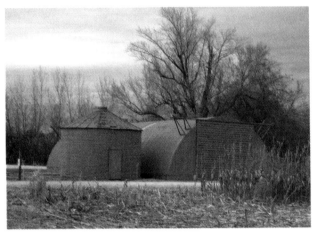

1 Capture the Image
Take a photo to refer back to later.

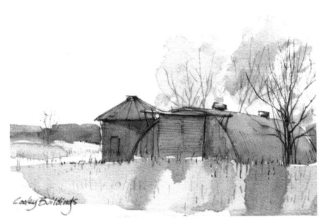

2 Simplify the Details
I used an old calligraphy-nib fountain pen for the lovely thick-and-thin, slightly unpredictable lines, simplifying the details and focusing on the shapes, then laid in wet-in-wet washes. I like the way they bleed into the warm foreground wash.

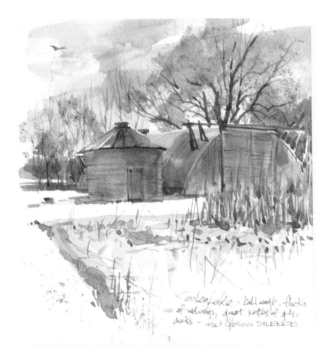

3 Make a Duplicate
Return to the same spot and recreate the same image to capture the differences.

Special Occasions

I celebrate occasions by getting out there and sketching, indoors or out. I always sketch on my birthday and on January 1, no matter what. I take what I call "compass readings," just looking back at the year and letting memory speak to me. Am I doing what I am meant to? Am I heading in the right direction for my soul? Am I happy?

I may do an image related to my musings, or I may not, but I always remember the day, what was going on and how I felt.

Most often this involves sketching or painting what I see— several pages of quick images or a slow, contemplative sketch where I take my time, enjoy the day, the process and the luxury of the opportunity to evaluate my life.

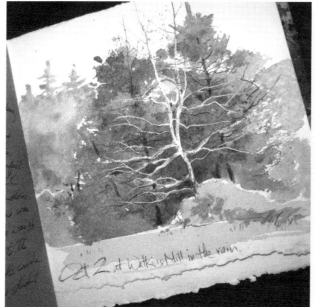

Birthday Sketch

The air was full of moisture and my paint was slow to dry—a perfect time to work wet-in-wet! I drew in the light tree with a white crayon to protect the main trunk, and laid in variegated washes to suggest the rainy forest, keeping the more distant trees simpler, cooler and bluer. "Jewels" of saturated Burnt Sienna stood in for the different types of foliage, and what drybrush I could manage under the circumstances worked for the dark cedar trees, along with a bit of spatter when the washes were slightly dried.

At upper-left in this on-the-spot rendering, you can see the effects of raindrops that blew in under the edge of the shelterhouse, making an interesting texture. Trunks and fine white branches were added later when everything was dry.

Birthday Scenery

This is what I saw on my birthday in 2014, sitting in a shelterhouse in a nearby state park as the gentle rain fell on the forest. I had driven around for some time, but this complex interweaving of branches and subtle colors seemed to express my life at just that moment in time, so I stopped to work.

Memories

Why not capture your memories while thinking about something you care about? Relive the good times as you work and I almost guarantee your memory will serve up tidbits you thought were totally forgotten. A special place you remember from childhood, a return to a friend's country home, a vacation spot where you used to camp with Mom and Dad, a sketching trip to your old school or church, or your first home—as a child or as an adult out on your own—all these are rich sketching subjects.

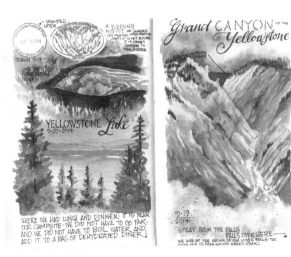

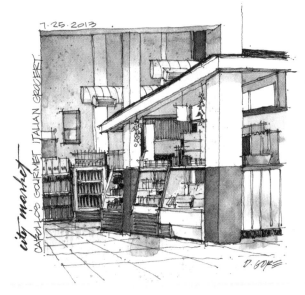

Favorite Places

Gay Kraeger returns to favorite places and fills her journal with sketches. Here, she has captured three views on facing pages. Her written notes add a great deal to the pages, both visually and as a memory trigger.

She feels free to add elements later, like the stamp in upper left; it adds depth and texture to the page as well as to the experience.

New Mediums

Don Gore has sketched at Kansas City's City Market many times. On this occasion, he chose to do a colorful, intimate interior. Consider taking a new look at a favorite place. Try a new technique or medium or color combination. Update a memory with today's perspective.

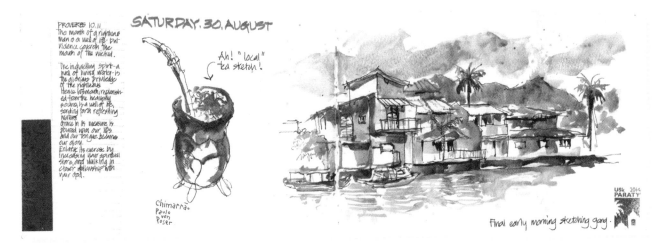

Fast and Loose

Of course, creating new memories is wonderful as well. World traveler Liz Steel has attended many of the Urban Sketchers symposia around the globe. This image is from one in Paraty, Brazil, and you can bet she has many other incredible memories stored in the pages of her journals. She's also a huge fan of tea; here you can see her early-morning brew as she works fast and loose.

What You Can Learn

Working on the spot is one of the best ways to learn about your subject, as well as to understand your feelings about it. You can do a nature journal sketch, drawing what you see as carefully as you can, making notes and asking yourself questions right on your page. You can always "consult the oracle" (the Internet!), look in a field guide or check with an historical society or museum.

Sometimes I find that my sketches tell me something about myself that I need to know or deal with. That's the miracle of creativity married to attention.

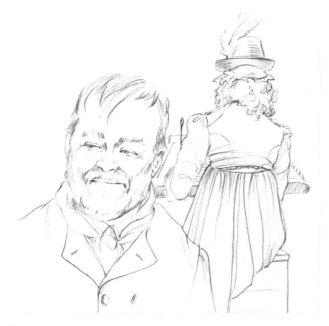

Forebearers
Marc Taro Holmes sketched at a re-enactment in New France. These events are wonderful places to learn about the lives of our forebearers. Strike up a conversation, ask questions or, better yet, get involved!

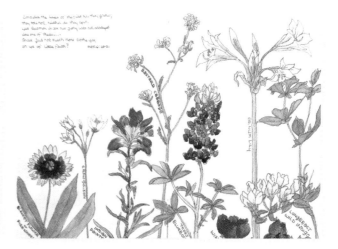

Flowers
History, people, towns and nature, like these wildflowers, all appear in Vicky Williamson's journals. She draws directly in ink, then adds watercolor later. This way, if she's unfamiliar with the plant, she can research it further.

Music
Barbara and Dennis Duffy are good friends and musicians who often perform at re-enactments, playing period music and dressing appropriately for the event. I always sit nearby so I can sketch with a soundtrack!

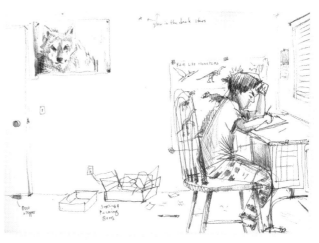

Children
Nina Khashchina caught her son in the act of learning. When your kids are absorbed in homework (or TV or a video game), this may be the ideal time to draw them since they're usually relatively still.

Heart Homes

My favorite sketching-on-the-spot subjects, which I return to again and again, are what I call *heart homes*. These heart homes are places I love, places I have sketched in all types of weather and all seasons. I never seem to tire of them, and I often return to them when I'm feeling wiped out or stressed.

Cooley Lake is one of these places. You'll have seen other images from this same place, between remaining pools of this old oxbow of the Missouri River. It's endlessly fascinating, full of history and wildlife. The sky is huge there in the river bottoms, and the bluffs nearby hem in the land and the lake. Here are three seasons: spring, fall and winter.

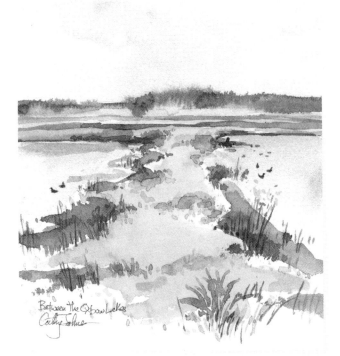

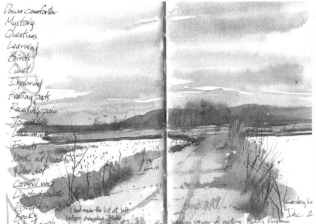

Exercise

Give yourself a few moments of quiet to think. What speaks to you? Where do you feel most at home? What calls to you again and again? What engages you on a soul level? Go there and sketch. Then do it again, in a few days, weeks or each season—whenever you feel that call.

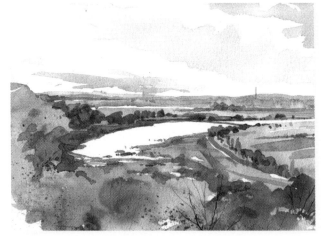

Alternate View

Consider another viewpoint of your favorite heart home. This was done at the top of a windy observation tower far above Cooley Lake on an autumn day.

Favorite Spot

The final picture includes one of my "gratitude lists" as well as evidence that I go there when I need healing. My eldest godchild had just passed away, and being out in that big landscape helped me to cope.

Demonstration

A Magic Moment

I grew up going to Bennett Spring State Park with my family. It's magical for me, and I'm delighted my husband loves it as much as I do. We go at least once a year.

I've painted the little waterfall just down from the spring on a number of occasions, sitting on the bank or a nearby bench. I'm always trying to capture the tumult of the water and my love for this place. One million gallons of water rush over the falls every day—always moving, always the same.

1 Preliminary Sketch
I created a preliminary sketch to study the shapes the water makes as it rushes over the moss-covered rocks.

2 Add Color
I painted around the white water and scraped a few highlights once the washes were dry. Pay attention to the shapes the water makes as it rushes over the rocks—let the brush dance through this part. Let the lighter green wash bleed into the dark rocks to suggest the texture of moss.

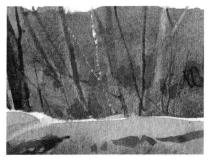

3 Paint the Trees
I painted the fall trees on the distant bank mostly wet-in-wet, scraping in a few lines while the wash was still damp to suggest smaller trees. I waited until the wash began to lose its shine to scribe lighter lines to suggest larger trees. After letting it dry, I added the darkest trees with a rich wash of Ultramarine and Burnt Sienna.

4 Add Water Reflections
I used Cadmium Orange for some bright touches of color on the far bank and in the reflections in the water.

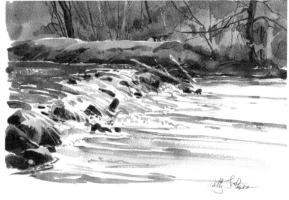

5 Add Texture
I used the texture of the paper in the foreground water to help make drybrush marks.

Making Changes

When we work on the spot, we may need to be prepared to work quickly or change direction. We may have one plan for a page and end up going somewhere else entirely with our images. Our initial subject may move or change position, or weather may chase us indoors. Sometimes I just keep adding until a page is full. Then I either try to pull it all together into a harmonious composition, or I just leave it alone. Either way, it still reflects a moment, or a collection of them, in any given day.

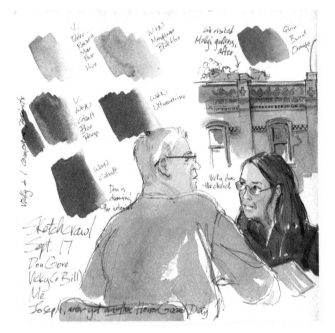

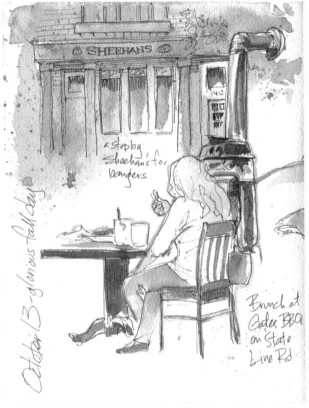

Exploring Palettes

Our sketchcrawls are often full of experiments and sharing. Here, my fellow sketchers offered their palettes to explore different brands of pigments like Quinacridone Burnt Orange.

I made samples right on my page, but then went on to add Don Gore and Vicky Williamson (both of whom are in this book) as we sat in a local restaurant. Not finished yet, I added the fancy brickwork in the building up the street. The green of the building's trim, the soft green trees and Don's shirt helped to pull this all together.

Holding Things Together

I just kept adding as I went along from lunch at one end of the city to the Irish store at the other. I let color and spatter help hold the images together and had the foliage appear on both sides of the stovepipe.

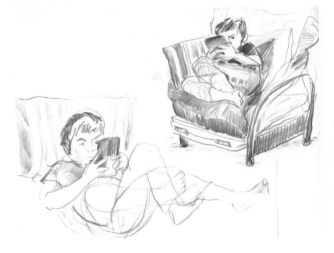

Capturing Youth

Quite often, people move as we attempt to sketch them, especially youngsters. Nina Khashchina solved that by simply drawing her sons' various positions and capturing something of the kinetic nature of youth. She did both of these sketches on scrap paper, then pasted them into her journal to keep.

Gratitude

Of course I'm grateful for being able to get out and sketch on the spot, and that I have the hand and eye connection to practice and improve.

But in addition, a life-changer, for me, has been keeping gratitude lists. Often, I keep one of exactly what I'm seeing and sketching on the spot, other times of unrelated things.

Text of any sort can add a strong graphic element, but I especially find these gratitude lists useful. I see the dozens of small things I might otherwise overlook, and the more I see, the more I have to be grateful for. I am more constantly aware.

List Making

I make these lists two to three times a week. This one was done in the Ozarks, sitting on the porch with fresh coffee after a night beside the fireplace. I usually make the list down the side of the page and then enjoy tying it together with the other images using calligraphy in a harmonizing color.

Dealing With Challenges

Life is full of challenges, so why not reflect that in our art? Dealing with changing weather conditions, life changes, painting in unusual circumstances, dealing with loss, recording events—these things can bring your art to a new and meaningful level.

Exercise

Practice quick-sketching on something that moves, like a pet, toddler, baseball players or birds at the feeder. Just get down what you can—the gesture, the basic shape. You can always add color or more detail later, especially if your subject returns to roughly the same position. It's great practice!

Movement

You may find that sketching a moving object is both fun and challenging. My huge goldfish, Normal, seldom holds still for a moment. As a result, I just fill a page with images, using a variety of mediums.

Creativity First

What do you think of when you consider the word *creativity*? I like to think of it as being open to inspiration—being in the midst of capturing an image and suddenly thinking: *I wonder if that would work or I think I'll try this.*

Maybe you're reading a book and a word or concept sparks your interest. Maybe performance art, ballet or Irish dance makes you see in color, and you long to capture your impressions.

Whatever occurs to you, at least consider it, no matter how far outside your comfort zone it may be. Listen to your muse speaking. There's no need to play it safe—the drawing police won't come and drag you away. There are no rules!

Textures

Here are some fun, simple things you can try if you're in the mood. In the upper left there's salt in a damp wash; in the upper right, clear water spattered into a wash that's just losing its shine. Below are some of the things you can do with those "hand-y" tools—your hands! Pat your fingertips into a wash and then on paper to make a beard-like texture. Use your whole hand in a wet wash, or make little critters with those fingerprint marks.

Try a Different Format

Who says you have to use standard shapes or sizes just because sketchbooks and art paper usually come in the expected rectangular format for vertical and horizontal orientation? Break out of the norm! Go for an extreme horizontal or extreme vertical. This is just what the two Dons did below, with different and creative end results.

Vertical Subjects

Don Gore excels in full-frontal views and capturing colorful buildings, from Colonial Williamsburg to downtown Kansas City. Here, he's focused on a strong, narrow vertical subject, showcasing the red door and beautiful brickwork.

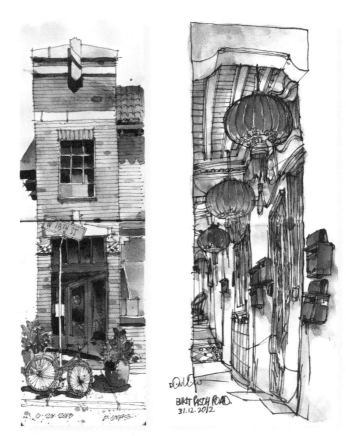

Extreme Perspective

Half a world away, Don Low goes for an extreme perspective, condensed into a similar vertical. The receding red lanterns and mailboxes invite us to wander down the narrow lane.

The Unexpected

Perhaps something unexpected happens, and rather than react with dismay and a loud "Oh, no!" we can think, "Hmm, well that was a surprise. How can I incorporate that?"

An inadvertent drop of paint can become a whimsical image, or you can add more spatters for intentional interest. Thinking and reacting on-the-fly sometimes produces my favorite images. Not everything is under control, nor need it be.

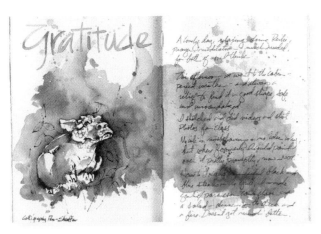

Smearing

I thought the ink I used to sketch our little backyard dragon was waterproof, so I was startled by the sudden smearing. I decided to go with the flow, as it were, and encourage the soft grays that the dampened lines produced, to suggest volume and shadow.

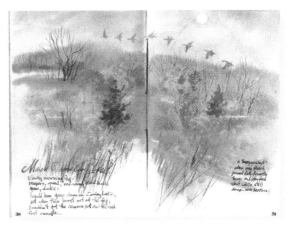

Dirt Happens

Cooperating with nature can be liberating as well as creative. I'm glad I didn't give up on this image when it landed in the dirt fifteen feet below! I decided I loved the texture in the trees on the hill, so I went ahead and finished the image in my journal.

Demonstration
Watered Down

I usually continue to paint on the spot in less-than-conducive conditions, even in a drizzle. Sometimes it helps me to capture the mood, but sometimes the result is startlingly effective.

Materials
1" (2.5cm) flat brush, no. 8 round brush, assorted watercolor pigments, cold-pressed watercolor paper

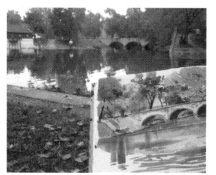

1 Find the Perfect Spot
I sat partly protected by trees and began drawing. (It was our last day at Bennett Spring State Park and I wasn't about to give up my chance to sketch on the spot!)

2 Splatter Small Droplets
I applied spatter to make the sparkle of the small droplets in the water in the foreground.

3 Create Foliage
I applied a loose wash to suggest foliage.

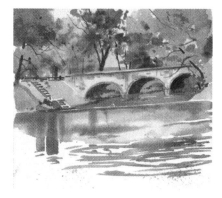

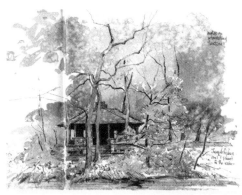

4 Add Final Details
More texture was added, and I applied final details to finish.

Dramatic Effect
Another year, on different paper, I got an even more dramatic effect! This one is a bold ink sketch made with a bent-nib calligraphy pen, and with watercolor splashed on afterward. The bright, strong pigments reacted to the lightly falling rain.

Exercise

Paint more than one of the same place. The light may change, or you may decide to try a different tack entirely. Maybe you want to take advantage of the texture of a new paper you're trying out, or a pigment you're experimenting with.

Shadow Play

Do you see a bit of blue or violet in that shadow? Why not paint it that way only using blue or mix in a bit of Quinacridone Rose for a beautiful violet? Shadows don't have to be dull! Vary them. There's often reflected color visible in a shadow, close to the object that casts it.

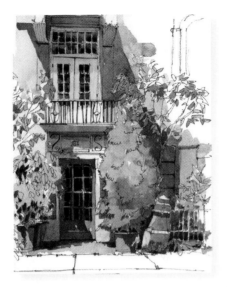

Reflected Light

Shari Blaukopf uses a clear violet for the shadow on the lower floor of this building, suggesting reflected light from the sunny sidewalk. It makes a much livelier effect than if she'd chosen to use grays for her shadows overall.

Primaries

Sometimes I leave my primary subject unpainted and only paint the shadows, making them as colorful as I like. Here, I used the primaries to make delicate tints that captured something of the prismatic nature of light.

Imagination

Sometimes being playful opens new doors to the imagination. You look at a knot on a gnarled tree with the eyes of a child and see a fae being, instead. Your dog morphs into another creature altogether—or your boss does! (There now, doesn't that feel better?!)

Altering Forms

A neighbor's beagle gave me the pose, and I took off from there! Baby dragon? Stick faerie? Why not?

Finding Fiction

I often pick up bits of old wood or tree roots and see things in them. This grinning, warty, tree troll hangs in my studio now, after kindly modeling for me.

Go With the Flow

Sometimes, when we try out a new tool or medium, we think we know what to expect—but we don't! I stopped by my favorite Las Vegas art supply store to pick up a brown technical pen, and I tested it before using it. I knew I wanted to add watercolor washes, and all was well; no lifting and no spreading. But when I did this sketch in my journal and added the first washes, I discovered that different paper can behave very differently, indeed!

Materials

1" (2.5cm) flat brush, no. 8 round brush, assorted watercolor pigments, brown fiber-tipped pen, salt, watercolor paper or sketchbook

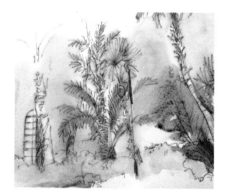

1 Accidental Halos
I applied the initial washes and sprinkled on some salt. (You can see the halo around my brown lines after I laid in the first washes.)

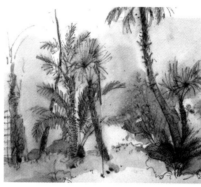

2 Remove the Salt
After the first washes dried, I removed the salt to get a bit of texture in the foliage. I add rich secondary washes to some areas.

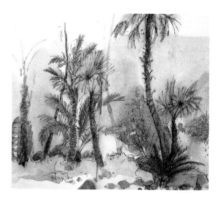

3 Add Palms
I added palms and the window beyond the tree, then I let everything dry thoroughly.

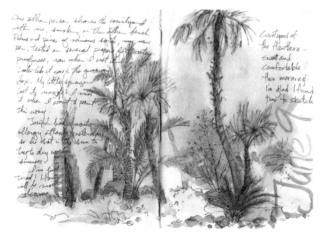

4 Add Final Details
When it was dry, I wrote the date and added some journal notes to finish the spread.

Index

Contributors

Thank you to all of the artists who generously contributed their work to this book. View the full list of contributors at www.artistsnetwork.com/artists-sketchbook-contributors.

Dedication

To my Joseph, who loves, encourages, inspires, spoils me rotten and makes sure I'm properly fed.

fw

a content + ecommerce company

Other fine North Light Books are available from your favorite bookstore, art supply store or online supplier. Visit our website at fwcommunity.com.

20 19 18 17 5 4

Distributed in Canada by Fraser Direct
100 Armstrong Avenue
Georgetown, ON, Canada L7G 5S4
Tel: (905) 877-4411

Distributed in the U.K. and Europe
by F&W Media International LTD
Brunel House, Forde Close, Newton Abbot, TQ12 4PU, UK
Tel: (+44) 1626 323200, Fax: (+44) 1626 323319
E-mail: enquiries@fwmedia.com

Distributed in Australia by Capricorn Link
P.O. Box 704, S. Windsor NSW, 2756 Australia
Tel: (02) 4560-1600; Fax: (02) 4577 5288
E-mail: books@capricornlink.com.au

ISBN 13: 978-1-4403-3880-9

Edited by Brittany VanSnepson
Production edited by Noel Rivera
Designed by Corrie Schaffeld
Production coordinated by Jennifer Bass

About the Author

Cathy Johnson has been making art since dirt was first flaking off the rocks and dinosaurs roamed the earth; she's been known to say she misses the taste of a good pterodactyl burger.

She is an artist, writer, teacher, naturalist, wanderer, gardener, traveler, wife and mother to an ever-changing herd of cats. She has written thirty-five books and innumerable magazine articles.

She offers online art classes at **cathyjohnson.info** and spends as much time as possible out in nature—art supplies in hand.

Acknowledgments

As always, a book is the result of many hands and minds. In this case, my heartfelt thanks go to all the artists who so generously shared their work here. To my editors, Brittany VanSnepson and Noel Rivera, and designer Corrie Schaffeld for their brilliant work on a huge, unwieldy pile of art and words. (I always overproduce!) To Jamie Markle, publisher, who continues to believe in me year after year. And to my dear husband, Joseph Ruckman, who supports me through everything, thick and thin. Any mistakes in this book are my own, and I sincerely apologize!

Metric Conversion Chart

To convert	to	multiply by
Inches	Centimeters	2.54
Centimeters	Inches	0.4
Feet	Centimeters	30.5
Centimeters	Feet	0.03
Yards	Meters	0.9
Meters	Yards	1.1

Ideas. Instruction. Inspiration.

Receive FREE downloadable bonus materials when you sign up for our free newsletter at **artistsnetwork.com/newsletter_thanks**.

Find the latest issues of *The Artist's Magazine* on newsstands, or visit artistsnetwork.com.

These and other fine North Light products are available at your favorite art & craft retailer, bookstore or online supplier. Visit our websites at artistsnetwork.com and artistsnetwork.tv.

Follow Artist's Network for the latest news, free wallpapers, free demos and chances to win FREE BOOKS!

Get your art in print!

Visit **artistsnetwork.com/competitions** for up-to-date information on Splash and other North Light competitions.